IMAGES
of America

ASOTIN COUNTY

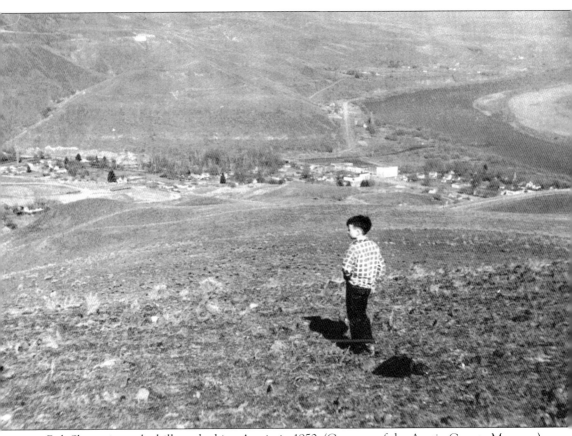

Bob Shaner is on the hill overlooking Asotin in 1950. (Courtesy of the Asotin County Museum.)

ON THE COVER: This award-winning photograph of the Asotin Memorial Bridge was taken by Keith Johnson. The bridge was built in 1919 solely by donations and replaced the earlier metal one. The bridge is a permanent memorial to all the men and women who have served in the military of this country. It was dedicated on November 11, 1922. (Courtesy of the Asotin County Museum.)

IMAGES
of America

ASOTIN COUNTY

Jeri Jackson McGuire

ARCADIA
PUBLISHING

Published by Arcadia Publishing
Charleston, South Carolina

Printed in the United States of America

Library of Congress Control Number: 2016930455

For all general information, please contact Arcadia Publishing:
Telephone 843-853-2070
Fax 843-853-0044
E-mail sales@arcadiapublishing.com
For customer service and orders:
Toll-Free 1-888-313-2665

Visit us on the Internet at www.arcadiapublishing.com

This book is dedicated to JoAnne Shaner Miller for her love of Asotin and love for the pioneers who made this county. She cares about the sufferings and hardships they endured to make this area home. Descended from pioneer Thomas G. Bean, she has a deep love of the land. She is the curator at the Asotin County Museum, and the past president. I am indebted to her for all the help she has given me in compiling this book. She and others wanted their stories told. (Courtesy of JoAnne Shaner Miller.)

CONTENTS

ACKNOWLEDGMENTS

The list of people to thank seems to increase exponentially with each book. I am grateful to so many who have encouraged me along the way, including my gifted editor, Henry Clougherty. Steven Branting, and all those who gave of their time and lent me their photographs, I thank you. I was honored to have been able to interview 87-year-old Marvin Jackson; three 92-year-old citizens of Asotin, Marian Fredrickson Nelson, Max Halsey, and Abe Wilson; and 95-year-old Eunice Halsey. Thank you for sharing your memories. Special thanks to JoAnne Shaner Miller and the Asotin County Museum, without whom this book could not have been written. A special, big thank-you goes to Susan Teague and all the help she has given me with photographs and insights on growing up in Asotin County. Thank you to Gary Hanchett, the very first person to lend me his album and memories; Marla Wilson Doty; Judy Ward Karlberg; Bruce and Jenny Petty; Gary Floch; Mr. and Mrs. Quinten Parsons; and many, many more for their photographs and memories. To my husband, Jim, thanks for going through this with me one more time. To my amazing kids, Ron and Teri McGuire, for generously letting me stay at their home on all my many trips to the valley for research, and to our son and his wife, Matt and Herta McGuire, and to Brandi and Darrel Sisco for their undying support. They have all been my cheerleaders, along with my extended family, Loretta Fisher, Rhyann and Carson Sanders, Lynann and Justin Duggan, and Brock Richie. Special love to Dani and Kip, Kade and Sara, Andrus, John and Kim Jackson, and Brianna Jackson. It is deeply appreciated.

INTRODUCTION

What do Pres. Thomas Jefferson, the explorers Lewis and Clark, the Nez Perce Indians, Washington Irving, Chief Joseph, Capt. (later colonel) Edward Bonneville, Chief Looking Glass, and Chief Timothy all have in common with Asotin County, Washington?

Jefferson directed Lewis and Clark to discover the West. Their Corps of Discovery camped with Chief Timothy on the banks of the Clearwater River. The location of Asotin today was originally the summer camping ground of the Nez Perce Indians. Irving wrote in *The Adventures of Captain Bonneville* that Bonneville left the military to become an explorer and was one of the first white men to travel to the region. At first, the Indians were shocked when they saw him. He was bald by then, and the Indians thought he had been scalped. From then on he was called the "Bald Chief."

Chief Looking Glass led his band of Alpowai Nez Perce, including many from Asotin, in joining Chief Joseph's campaign against the US cavalry and local militias, generating anxiety and even panic among white settlers. Some simply left the region, while others stayed and constructed defenses in the event violence reached the rivers towns. Locals converted the homes of Maguire and William Hopwood into forts, but they were never needed. Chief Joseph and his followers headed in the opposite direction, toward the Bitterroots, facilitating a return to normalcy in Asotin.

From 1855 and the signing of the so-called "Stevens Treaty" until the agreement was renegotiated in 1863, the territory that is now Asotin County was a part of the Nez Perce Reservation, the western boundary of which ran between Alpowa and Pataha. Asotin County was carved out of Garfield County on October 27, 1883. The town Asotin, which was named the county seat, dates from 1878 due to the efforts of Alexander Sumpter.

Pioneers with names like Bracken, Smith, Maguire, Weissenfels, and Peaslee left their homes faraway and made the trip out West, suffering many hardships both along the way and after they settled the area. They befriended the Indians, who helped them harvest their crops. There were no roads, only trails. The Snake River frequently froze over. Local resident Abe Wilson remembers that when he was five years old, he and his twin brother were playing on the ice. They soon tired, went home, and fell asleep, only to find out later that the entire town was out looking for them, thinking they had drowned.

As time passed, post offices, churches, and schools rose on the skyline, bringing a sense of community to the region.

However, Asotin County—which once included the towns of Anatone, Theon, Cloverland, Silcott, Peola, Clarkston, and Alpowa—was the "wild west" in the truest sense, where frontier justice was not infrequently meted out by masked men lynching criminals right on town streets without benefit of a trial. Those were the days of gambling, dancing, horse trading, and cattle rustling. The bodies of murdered Chinese miners could be seen floating down the river.

Arsonists set the county courthouse in Asotin on fire, as Clarkston had long wanted to be the county seat and that seemed to be the quickest way.

On August 5, 1931, twelve-year-old Herbert Niccolls Jr. shot and killed county sheriff John Wormell after the sheriff and a deputy responded to a report of a burglary in a store at the intersection of Second and Cleveland Streets. Niccolls was held at the Pomeroy, Washington, jail while his front-page trial was conducted in Asotin, leading to the boy's conviction and a long prison term. Fr. E.J. Flanagan, the founder of Boys Town, made a nationwide appeal for Niccolls's "parole" to Boys Town for his release.

The location of Clarkston was dominated by sagebrush and sand in those years. The Clemans Addition in Asotin was once a pasture for livestock. Lewiston was the main focus for the Columbia-Snake River riverboat trade, although the steamers made weekly trips up past Asotin to the mines on the Grand Ronde and Imnaha Rivers.

Cassius C. Van Arsdol visited Jawbone Flats in 1893 and, along with Edgar Libby and Charles Francis Adams, joined other businessmen who bought out the water rights and property for the construction of an open ditch irrigation system that conveyed water to a quarry used for a catch basin above Asotin. The result was a steady and reliable supply of domestic and irrigation water. Many an Asotin home had its foundation built from basalt quarried during the project.

The rugged terrain of the county created the conditions for repeated and disastrous flooding. Asotin Creek overflowed from a flash flood in May 1897, causing considerable damage but inflicting no fatalities. A flood in June 1925 killed two young children from the same family. Flooding continued to be a regular threat into the 1970s until the dam system on the upper Snake brought the river under control.

In the 1950s, Asotin's growth had become stagnant, like many small towns bypassed by the highway systems. The new interstate system favored the larger trading centers, like Lewiston and Spokane. Fortunately, Washington planners upgraded State Routes 128 and 129.

Asotin County is recognized as a region of outstanding beauty and historical significance. Known as part of the "Banana Belt" since the 1920s, the county enjoys a mild climate, allowing for year-round outdoor recreation, including golf, tennis, and baseball. One can choose from an array of activities—water skiing, sailing, fishing, hunting, swimming, camping, walking, or riding along the miles of paved levee pathways.

Today, the calendar of events is dominated by the Asotin County Rodeo and Fair, which celebrated its 75th diamond jubilee in April 2016. Cosponsored by the Asotin Lions Club, the Grange, the Wheelers, the Asotin County Cattlemen and Cattlewomen Association, and many other organizations, the fair proves to be very popular not just among county residents, but with people from around the region.

In this companion volume to Images of America: *Clarkston*, explore the heritage and events, the byways, and people that have made Asotin County what it is today.

One

A NEW WORLD

HOW ASOTIN COUNTY EVOLVED

Asotin County was first a part of both Walla Walla County and Columbia County, which comprised a total of three counties—Asotin, Garfield, and Colombia. They were divided into three separate counties by the territorial legislature on November 11, 1875. Belle Critchfield used to say that she lived in three counties without ever having to move. (Courtesy of Marla Wilson Doty.)

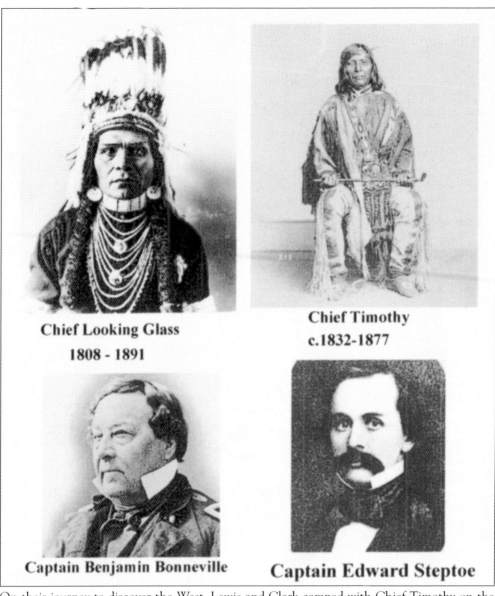

Chief Looking Glass
1808 - 1891

Chief Timothy
c.1832-1877

Captain Benjamin Bonneville

Captain Edward Steptoe

On their journey to discover the West, Lewis and Clark camped with Chief Timothy on the banks of the Clearwater River. The spot that is Asotin today was originally the summer camping ground of the Nez Perce Indians. Author Washington Irving wrote in his book *The Adventures of Captain Bonneville* that Captain Bonneville left the military to become an explorer and was one of the first white men to travel to the area. At first, the Indians were shocked when they saw Bonneville, as he was bald then, thinking he had been scalped. From then on he was referred to as the Bald Chief. (Author's collection.)

Asotin Creek, Clarkston, Wash.

Apash Wyakaikt acquired his more familiar English moniker, Chief Looking Glass, upon meeting expedition leaders William Clark and Meriwether Lewis for the first time in 1805. They distributed gifts of small, circular metal mirrors with an eyelet attached to the rim of each through which a cord could be tied. (Courtesy of the Asotin County Museum.)

For centuries before the first non-Indians reached the Northwest, this spot near the confluence of what are now known as Asotin Creek and the Snake River was a favorite winter resort for Indians of the region. A relatively warm winter climate and an abundance of freshwater eel in the mouth of the creek attracted a large annual encampment of Alpowai Nez Perce Indians. (Courtesy of Gary Hanchett.)

Captain Bonneville also had the pleasure of meeting Chief Looking Glass. He hosted Bonneville at his winter home near Asotin in February 1834. Bonneville and his party enjoyed a great feast, fine accommodations, and an array of entertainment for one night before pressing on towards Walla Walla. (Courtesy of Phyllis Hower Keith.)

Chief Timothy assisted Col. Edward Steptoe and helped lead his column to safety after being besieged by Cayuse and Palouse warriors near Rosalia, Washington. Timothy's band lived on the Snake River, just above present-day Lewiston. He was one of the Nez Perce leaders to sign the 1863 treaty. Timothy did not participate in the 1877 war and died in 1891. (Author's collection.)

The territory that is now Asotin County was once part of an Indian reservation in 1857. The reservation was a large territory halfway between Alpowa and Pataha; it eventually encompassed all of present-day Asotin. Asotin was named after the Indian word Has-shu-in, meaning "eel," as there were many eels in the Snake River. (Courtesy of Gary Hanchett.)

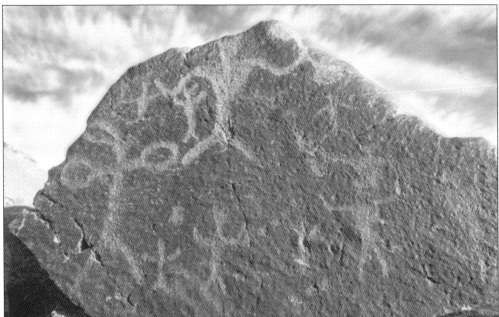

On either side of an area known as Buffalo Eddy, formed by a series of sharp bends in the Snake River, are found densely grouped clusters of petroglyphs and a few pictographs. These fascinating artifacts are evidence of the longevity of the Nez Perce in the region and contain hundreds of distinct images that possibly date from as early as 4,500 years ago. (Courtesy of the Asotin County Museum.)

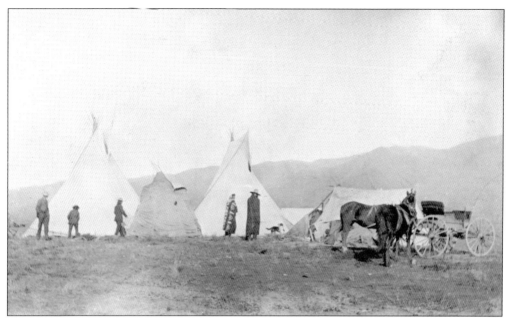

Previous to the Nez Perce war, the Indians and the white man lived in perfect harmony, with most of the Indians being held in high esteem for their honesty and friendliness. Chief Timothy remained loyal to the white man throughout, but some Asotin Indians joined Chief Joseph and went on the warpath. (Courtesy of Sherri Ross Willenborg.)

During the Nez Perce war, a few families in the Anatone region began to panic and fled. The settlers held on and decided to hold their homes but made preparations to defend themselves in case of attack. The residences of Jerry Maguire and William Hopwood were converted into forts. Fortunately for the pioneers, the Indians never crossed the Snake River. (Courtesy of Gary Hanchette.)

Two

WELCOME TO HARD TIMES

THE PIONEERS

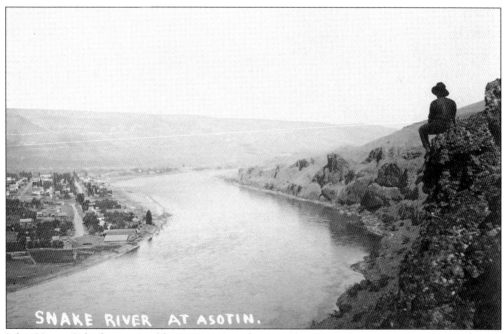

SNAKE RIVER AT ASOTIN.

John Henry Schiebe attained his squatter's rights in 1878, James Sangster arrived around 1877, and Bradshaw Hodges was the first registered homesteader in the Cloverland area in 1878. Later, Melvin Fred Reeves came from North Carolina in the 1900s, as well as the Nelsons, the Favors, the Nichols, the Ausmans, the McFarlands, and many more. Space does not permit naming them all, but some of the others will appear later in the book. (Courtesy of the Asotin County Museum.)

Robert "Bob" Bracken (1841–1906), pictured here, was the first man to settle in Asotin. Sam Smith had moved in near the confluence of Alpowa Creek and the Snake River. Smith opened a store and hotel to service travelers heading to and from the Orofino gold mines in Idaho. Smith soon left the region. Bracken established his first permanent home eight miles south of present-day Asotin in 1862. (Courtesy of the Asotin County Museum.)

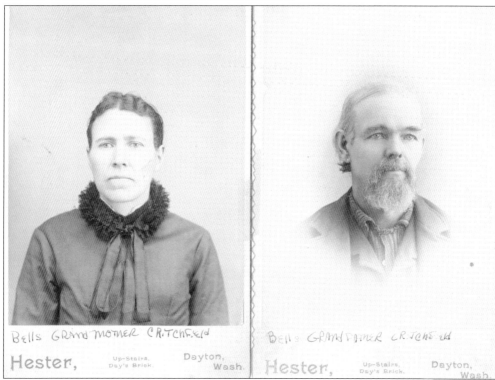

Bells GRAND MOTHER CRITCHFELd

Hester, Up-Stairs. Day's Brick. Dayton, Wash.

Bells GRANDFATHER CRITCHFELd

Hester, Up-Stairs. Day's Brick. Dayton, Wash.

Jenny and Henry Critchfield were two of the oldest pioneers. He was one of the founding fathers, a town leader, and one of the commissioners. He hauled trees for timber but also planted trees on Asotin's Main Street, and prepared land for Asotin Park. They built a home on Critchfield Ridge near Swallows Nest. (Courtesy of Gary Hanchett.)

This is Opal (Hulse) and Ed Wimberly on their wedding day. Opal was the daughter of Wade and Carrie Hulse, descendants of Jenny and Henry Critchfield. The photograph was taken by Lilly Art Studio in Spokane, Washington. (Courtesy of Gary Hanchett.)

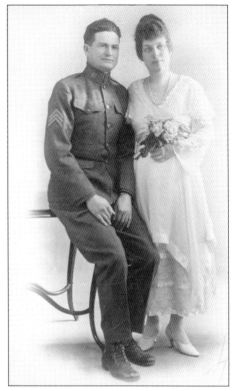

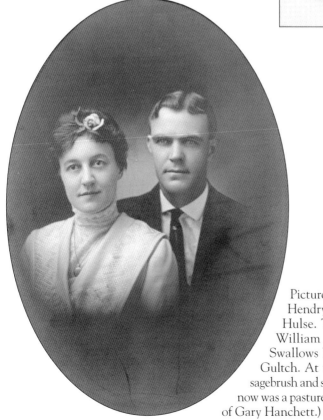

Pictured here are May (Critichfield) and Hendry Dodson. May was a sister to Belle Hulse. Their parents were Mr. and Mrs. William Critchfield, and they lived near Swallows Nest at the mouth of Critchfield Gultch. At that time, the Clarkston area was sagebrush and sand, and where Clemans Addition is now was a pasture for her father's livestock. (Courtesy of Gary Hanchett.)

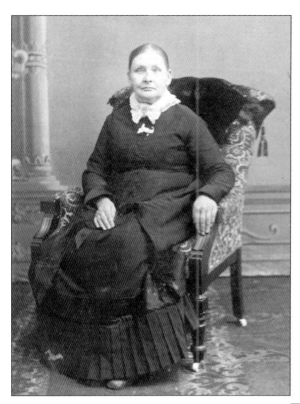

Thomas G. and Sarah Bean were also early pioneers. In 1877, Thomas Bean and William Parrish became partners in a sawmill and in the spring of 1878 moved from Columbia Center to Anatone. Early in the fall of 1878, the sawmill began making lumber. (Courtesy of JoAnne Shaner Miller.)

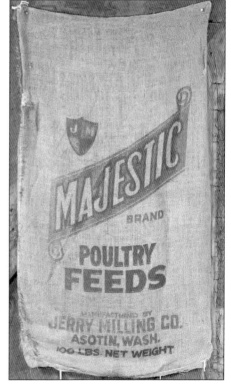

One of the earliest settlers on the little flat where the town now stands was Jerry Maguire in 1867. He moved up Asotin Creek in 1868, a short distance to the place that bears the name of "Jerry." He owned about 300 horses and a packing business and later opened Jerry Milling Company. (Courtesy of the Asotin County Museum.)

This is the interior of a home up on Pintler Creek. Settlers traveled long distances, bringing their families and goods from the East Coast and elsewhere. The *Sentinel* in January 1909 stated that "Anatone had a flour mill, two sawmills and a fine lot of farming country." (Courtesy of Gary Hanchett.)

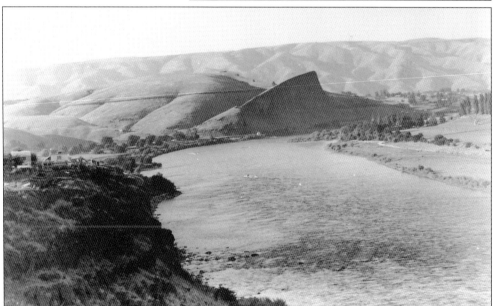

William J. Clemans came to Asotin in 1885 and opened a saloon. In 1899, he bought a merchandise store from Charles Isecke. He had many thousands of acres in Asotin County. George W.R. Peaslee first settled where Asotin now stands. He moved to just outside of Clarkston where he had a larger nursery and over seven acres of orchard and 18 acres of nursery stock. (Courtesy of the Asotin County Museum.)

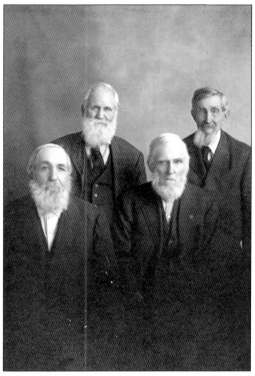

This photograph shows some prominent men from Asotin. From left to right are believed to be William Fordyce, Charles M. Brantner, Mr. Onstot, and John Wormell. According to 91-year-old Marian Nelson, in those days, they used the title "Mr." so often, sometimes people never learned a person's first name. (Courtesy of Marian Fredrickson Nelson.)

Mrs. Benjamin Floch

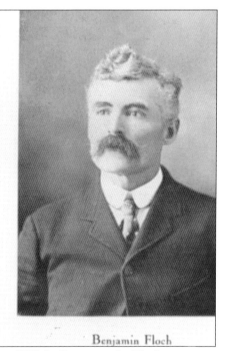

Benjamin Floch

The Floch families emigrated from Weler, Germany, in 1805. In Germany, the Floch name was spelled Flach. Christian Floch, son of Johannes, and wife Rhoda Thomas Floch came to Asotin County and homesteaded in 1879. Benjamin Floch, son of Christian, also filed his homestead in 1879. It is located east of Anatone on Weissenfels Ridge. (Courtesy of Gary Floch.)

Quinten Parsons's uncle Albert of Cloverland is shown on his horse Berg around 1940s. Albert bought Berg from the Army, which thought he was too small. The horse never liked Albert and tried to kill him on several occasions. Charles ("C.T.") Parsons, however, loved that horse. Albert gave him to C.T. In his will, C.T. left instructions that the horse was never to be killed and that he should live out his life naturally. (Courtesy of Quinten Parsons.)

Shown are, from left to right, the three Floch sisters, Eva Floch Sangster, Fern Floch Forgy, and Lillian Floch Chandler. These girls were Benjamin Floch's daughters and Travis Floch's sisters. Travis Floch was Forrest Floch's father. (Courtesy of Gary Floch.)

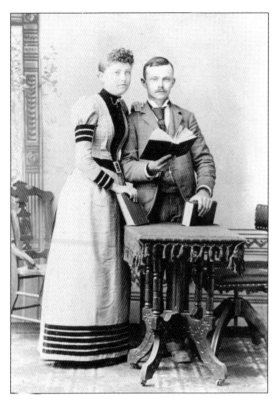

This is Joshua and Elizabeth Jones on their wedding day, April 13, 1891. Joshua, who was called "Grandpa Jones," was elected superintendent of Asotin County schools and served for 14 years. When he became principal, he went to work to make a name for the Asotin School. He systematically brought the school to a point where it was recognized as one of the best graded schools in the state. In 1903, he was elected councilman of Asotin. He was the Asotin Bank manager for 15 years, and then served as county treasurer until his death. (Courtesy of Judy Karlberg.)

Elizabeth Jones (Mrs. William D. Jones) is pictured on her family farm in Anatone. She was the mother of Elizabeth Jones; grandmother of Estyn Jones; great-grandmother of Joyce, Kent, and Peggy; and great-great-grandmother of Judy Ward Karlberg. She died in 1919. (Courtesy of Judy Ward Karlberg.)

These were the children of Joshua and Elizabeth Jones in late 1901. From left to right are (first row) Ethel, Mable (who died young of measles), and Edwin; (second row) Estyn, Roger, and Anna. Estyn later became the father of Joye Jones and grandfather to Judy Ward. (Courtesy of Judy Ward Karlberg.)

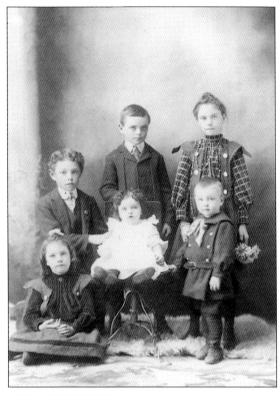

Abe and Peggy Wilson are pictured here. Abe's father was C.A. Charles Wilson, who was born in 1881 and moved from Missouri when he was young, around the turn of the 20th century. They had 12 children: Lee, Tom, Dick, Chuck, Iris, Frances, Mae June, Joy, twins Abe and Ted, and Merle. All are deceased except Abe. (Courtesy of Marilyn Pike Wilson.)

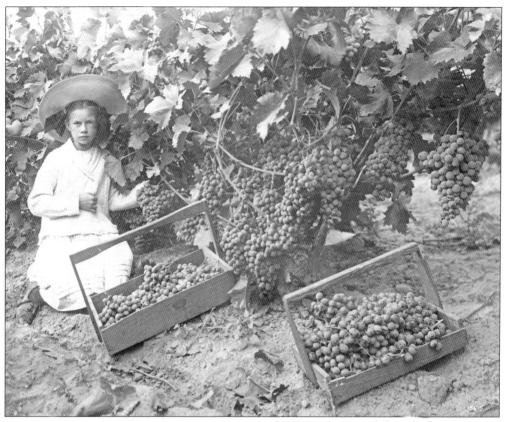

In this 1910 photograph by noted photographer Curtis Asahel, a young girl wearing a hand knitted sweater shows off especially large grapes that were produced in Asotin County. Notice the unique boxes they used to harvest the grapes. (Courtesy of the Asotin County Museum.)

Alfred and Ruby Hendrickson are pictured here on their wedding day, September 10, 1920. They were the parents of Marian Fredrickson Nelson. Ninety-two-year-old Marian remembers that when Max Halsey was a little boy, he needed a lot of love and her father nurtured him. Marian admits she was jealous of Max in those days. Sadly, Max died before this book was published. (Courtesy of Marian Fredrickson Nelson.)

This 1880 photograph shows the Fordyces' wedding license. Since Asotin was a territory at the time, they had to travel to Lewiston County in Nez Perce, Idaho, to get a license. Written on the back is "Recorded at the request of Jospeh K. Vincent, June 15, 1880, in Book E, page 179. Jonah Evans, Recorder." Washington became a state on November 11, 1889. (Courtesy of Marian Fredrickson Nelson.)

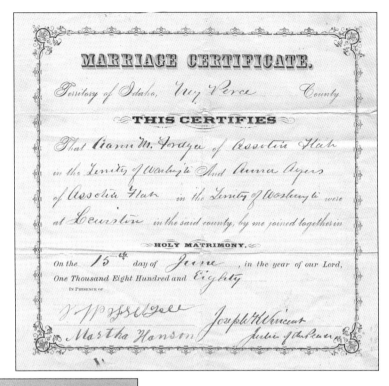

John (Ted) Petty and Annie Mae Parsons Petty are pictured on their wedding day, June 16, 1929. The Pettys were longtime farmers and ranchers in the Cloverland area. (Courtesy of Bruce and Jenny Petty.)

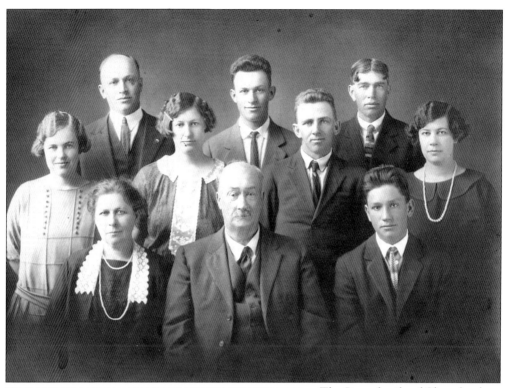

The Petty family of Cloverland are, from left to right, (first row) Mary Johnson Petty, John Petty, and Dick Petty; (second row) Pearl Benedick Petty, Maude Petty Parsons, Gene Parsons, and Grace McMillan; (third row) Wilber Petty, Ted Petty, and Art McMillan. (Courtesy of Bruce and Jenny Petty.)

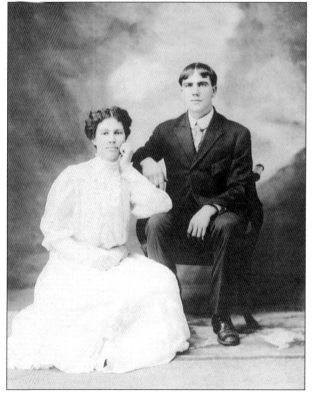

This is the wedding photograph of Charlie and Minnie Harryman, taken on September 9, 1907. Forrest Floch, son of Travirse, was born on the Travirse Floch homestead in 1910 and married Elmo Etta Harryman, the Harrymans' daughter. (Courtesy of Gary Floch.)

Anna Ayers Fordyce is pictured in her garden. William Fordyce purchased a tract of land on Asotin Creek in 1900. In addition to having orchards, he raised horses and sheep and was a very prosperous man. Marian L. Hendrickson was their granddaughter. A family member, Matilda Ann Beaucham, came from Missouri in 1845 in a covered wagon on the Oregon Trail as a 10-year-old child. She lived to be 99 years old. Her family was from England and included John Beauchamp, who was one of the financiers of the *Mayflower*. She is buried in the Asotin Cemetery. (Courtesy of Marian Fredrickson Nelson.)

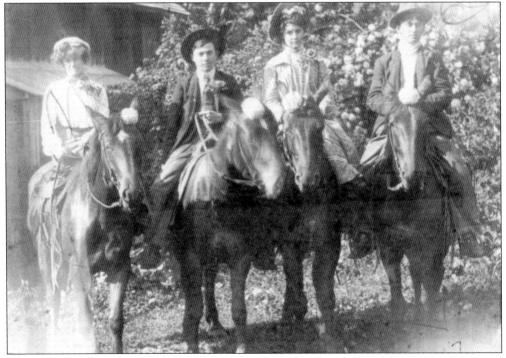

This photograph shows some local ladies riding sidesaddle. From left to right are Myrtle Stone, ? Tabott, Mable Lothrop, and Cress Stone. Myrtle and Cress Stone are Adealia Stone Jones's sister and brother. Note the flowers they have put on their horses. (Courtesy of Judy Ward Karlberg.)

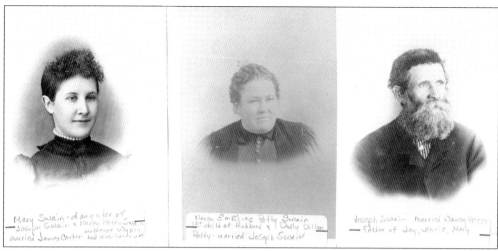

On the left is Mary Swain, daughter of Joseph Swain and Nancy Emeline Petty Swain (mother of Wyatt). Mary Swain married James Carter and had 14 children. In the middle is Nancy Emeline Petty Swain, the first child of Hubbard and Dolly Dillon Petty, who married Joseph Swain, seen at right. Joseph was the father of Jay, Jennie, and Mary. (Courtesy of Bruce and Jenny Petty.)

Stephen and Nannie (McKinley) Badger were the great-grandparents of Sherry Ross Willenborg. They owned a truck farm, growing peaches from 1911 to 1917. Because of the area's location in the Banana Belt, peaches were still growing in October. Stephen died 12 days short of his 76th birthday in 1918. Nannie lived at Ninth and Elm Streets in 1920. They are buried at Vineland Cemetery in Clarkston. (Courtesy of Del and Sherry Ross Willenborg.)

Ellsworth "Lee" Wilson poses for a portrait with his niece Annie (Lolly) Wilson on her wedding day around 1910. Her brother Lonnie married Leonidas "Onnie" Palmer in 1910. The Wilsons homesteaded near Pomeroy. There was another pioneer family named Wilson, but they were a different clan who farmed in the Asotin-Anatone area. (Courtesy of the Asotin County Museum.)

This portrait of the Weldon Wilson family was taken in 1901. From left to right are (first row) Calla Lily held by her mother Jenny, Mac, and Earl; (second row) Lafe, Weldon, Lolly, and Lloyd. Lolly married Leonidas "Onnie" Palmer in 1910. (Courtesy of the Asotin County Museum.)

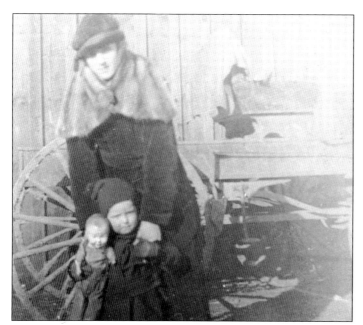

Ruby May Fordyce Hendrickson is pictured around 1926 with Marian L. Hendrickson when she was a toddler. The family were early pioneers in Asotin County. Marian's daughter Maggie Jones is the fourth generation born on the Fordyce/Ayers side. Maggie's grandfather on the Hendrickson side came to the area as a very young man. William H. Fordyce, a venerable and respected citizen of Asotin County, came from Indiana around 1878. (Courtesy of Marian Fredrickson Nelson.)

Marian Fredrickson Nelson's grandmother, Ruby May Foredyce, who was born on August 26, 1898, and is shown at right. Ruby's older sister, Pearl, is at left. This photograph was taken around 1918. Ruby's mother was Anna Ayers Fordyce. The Ayers were ranchers and also owned the Ayers Hotel in Asotin. (Courtesy of Marian Fredrickson Nelson.)

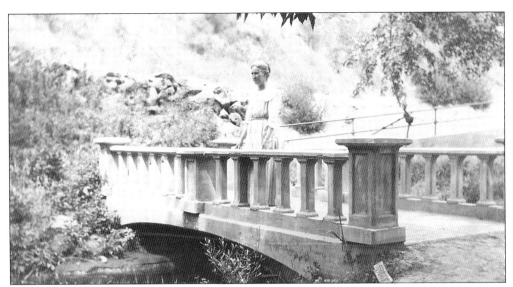

Shown on the footbridge across the creek in Asotin Park is Laura Stephens, wife of J. Stephens, around 1922. After the slack water came in, this bridge was placed flat on the ground. The park was used at times during the Asotin County Fair and is still there today. (Courtesy of the Asotin County Museum.)

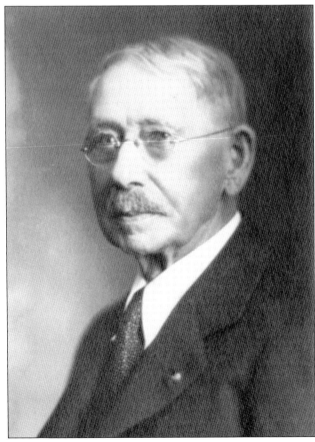

Edward Baumeister was practically the father of Asotin County. He was born in Germany in 1848, and in the fall of 1885, he came to Asotin and opened a general merchandise establishment called Baumeister & Company. He also had extensive holdings in real estate. (Courtesy of Gary Hanchett.)

Belle and Ray Hulse are pictured in Asotin. Belle's father was Henry Critchfield. Belle remembered traveling to Walla Walla past the massive Indian camps. The Indians came near the wagons and pulled on the blankets, attempting to motion in sign language that they wanted to trade. While traveling through Asotin to Wallowa, the Indians often traded with Belle's mother. They had a huge amount of huckleberries with which to trade. (Courtesy of Gary Hanchette.)

Three

A River Runs through It

Asotin

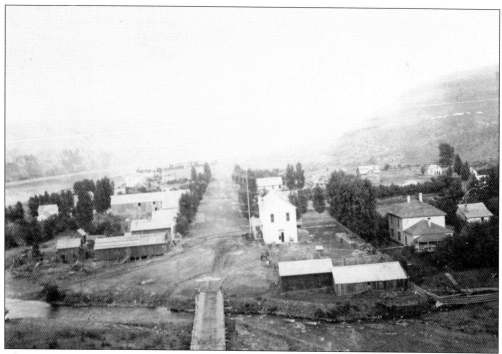

This is one of the oldest photographs of Asotin, taken around 1880. Nearest on the left is Sage's blacksmith shop, with a house behind it. Other buildings include John Steele's place, Baumeister's merchandise store, Bailey's, Morgan Tate's (Bertha Campbell's father), Guenkel's (saloon keeper), Mitchie's Saddle Shop, and Jake Rice's home. (Courtesy of Gary Hanchette.)

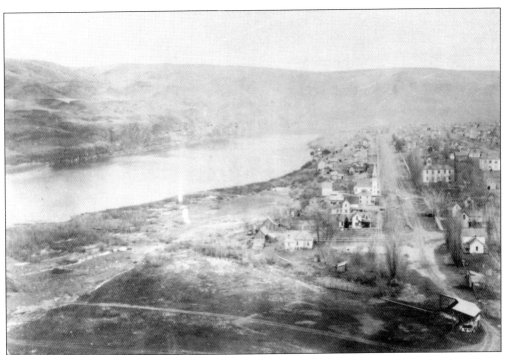

This is a view of Asotin around 1888. According to *History of Southeastern Washington*, a book published in 1906, Theodore Schank's cabin was the only building occupying the present business portion of Asotin in the early spring of 1882. It was not until December of that year that the townsite of Asotin was platted. (Courtesy of the Asotin County Museum.)

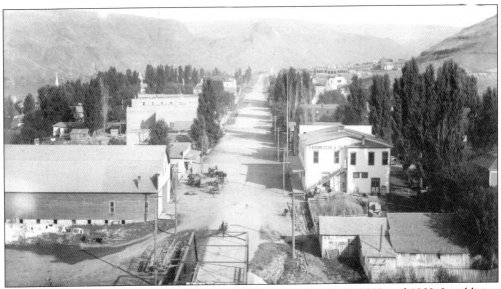

Water development facilitated the platting of additions to Asotin in 1899 and 1902. In addition to water, the construction of the county courthouse and a spate of other new buildings, including the town's first brick structure in 1899, helped usher Asotin into the 20th century. In 1902, Asotin boasted 1,065 residents, more than double its size of three years earlier. (Courtesy of the Asotin County Museum.)

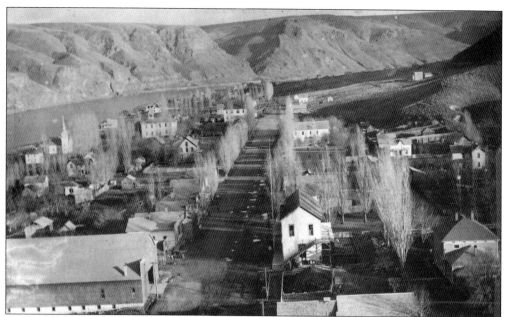

In the summer of 1888, Asotin contained two general merchandise stores, one drugstore, three hotels, two livery stables, one blacksmith shop, one butcher shop, one flour mill, one boot and shoe shop, one harness and saddle shop, one saloon, one millinery store, two dress-making establishments, one Chinese laundry, one newspaper, and two warehouses. It was a prosperous place with 300 people. (Courtesy of Gary Hanchett.)

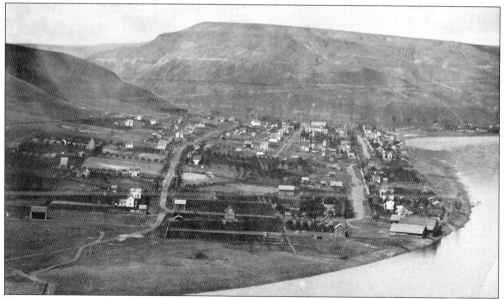

The two towns of Assotin City and Asotin were growing up about half a mile apart in the Asotin Valley. Assotin City to the east was platted by Alexander Sumter and began resembling a town around 1880. Asotin was platted in 1881. The new Asotin County came into official existence on November 12, 1883. In 1886, the residents of Assotin City decided to surrender to the inevitable, and in 1887, the last business was moved to the new town of Asotin, and peace reigned over the friendly, united village. (Courtesy of Gary Hanchette.)

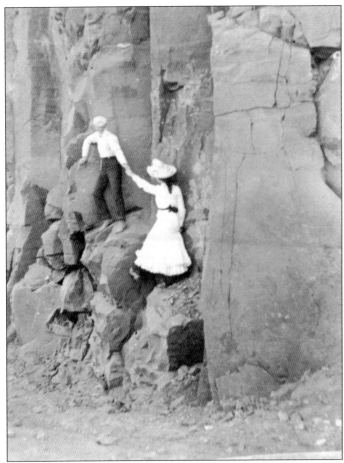

Belle Critchfield, the daughter of the town's dressmaker, Jenny Critchfield, was known for her beautiful clothes, which she wore even while climbing the rocks around Asotin County. Those who knew Belle remember her as a beautiful girl with red hair and classy gowns. At one time, Belle Critchfield Hulse was the oldest lifelong resident of Asotin. (Courtesy of Gary Hanchett.)

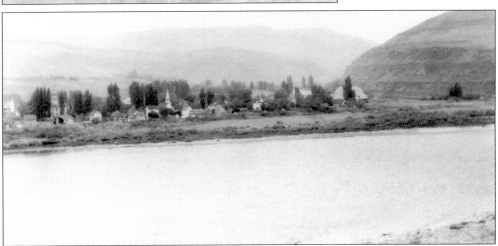

Belle Critchfield lived in the third house to the left of the big building, which was the delivery barn. She could see the hangings on First Street and saw the floating bodies of the dead Chinese miners after they were robbed, killed, and thrown into the river. This house still stands. It is the first house on the left after crossing the new bridge. It was later used as a boardinghouse. (Courtesy of Gary Hanchette.)

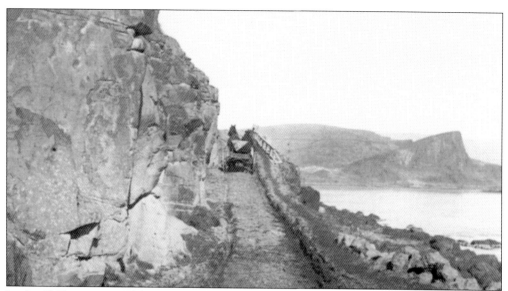

In the 1940s, a new road from Asotin to Clarkston traveled north. Swallows Nest Rock can be seen in the foreground. In 1912, as seen here, the old road was not paved, was not very wide, and was rough. Part of the old road can still be seen at this location; the rest was taken out during construction of the new highway. (Courtesy of Asotin County Museum.)

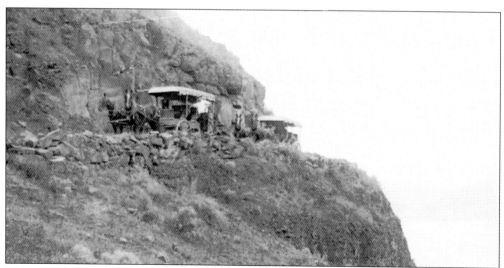

This is a 1912 view of the public highway near Asotin going towards Clarkston, five miles down the river. This was the first road to the Clemans Addition. (Courtesy of Asotin County Museum.)

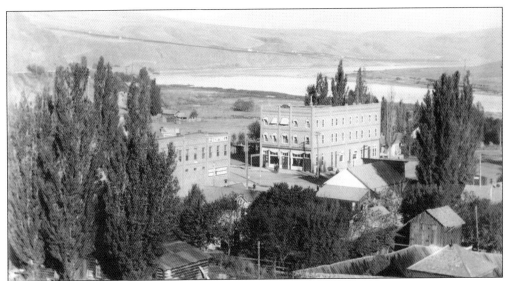

This is a view of the Ayers Hotel. From this angle, the irrigation ditch that went across the hill is also visible in the distance. (Courtesy of Gary Hanchette.)

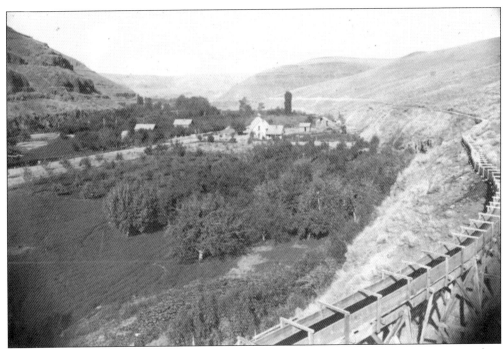

The water system was originated by an irrigation district around 1896. The water system was then transferred to Lewiston Water and Land Company. The original source of water for Clarkston and the surrounding area was Asotin Creek. The headgate was the source, which is 12 miles south of Clarkston. Water flowed by gravity to the Clarkston area through an open ditch (Old Vineland Ditch). In 1907, a 48-inch wood stave transmission main was installed to replace the open ditch. The new transmission main included irrigation service to the district known as Clarkston Heights. (Courtesy of the Asotin County Museum.)

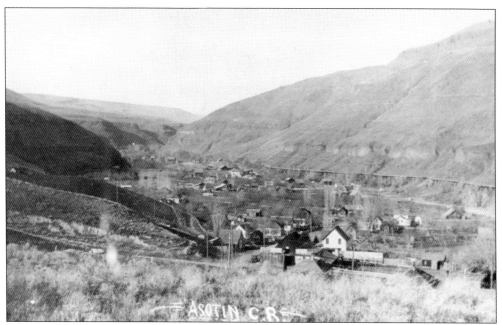

A continuous wood stave pipeline was built in 1906 to replace the open ditch. The new intake in the present reservoir in Pomeroy Gulch, also constructed in 1907, had a capacity of approximately 22 million gallons. In 1901, the first pipeline was installed from the canal near Pomeroy Gulch into the town of Clarkston for pressure service. (Courtesy of the Asotin County Museum.)

This photograph, taken in 1944, shows how water was piped from the headgates complex on Asotin Creek to the reservoir power plant in Clarkston Heights. The water traveled 14 miles from 1907 to 1964. The water went from Asotin to Clarkston, making it possible for people to grow crops. (Courtesy of the Asotin County Museum.)

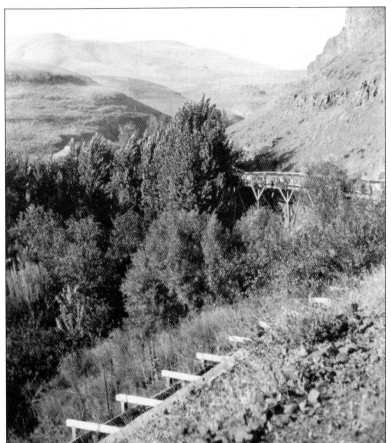

The lower flume shown here has water coming out from the headgates in the west. It provided water to the northwest end of Asotin, irrigating Clarkson from Asotin Creek. There were also higher flumes around the city of Asotin. (Courtesy of the Asotin County Museum.)

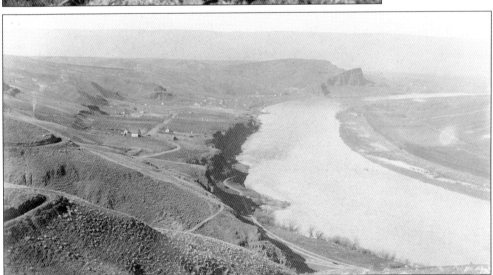

This view of the valley shows Clemans Addition looking north towards Clarkston. William and Jenny Critchfield built a home on top of Critchfeld Gulch, where their daughter Belle was born. The home was near Swallows Nest, which at that time was referred to as Critchfield Mountain. Belle went on horseback to attend Asotin's first school. (Courtesy of Gary Hanchette.)

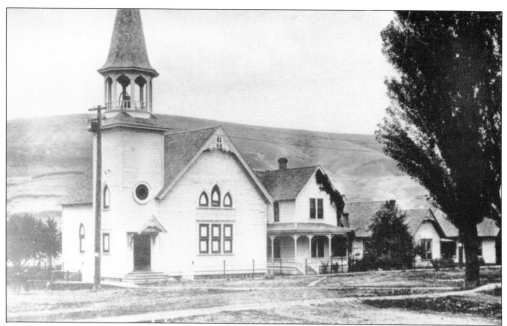

This 19th-century Gothic church was moved from its location on First Street to the 100 block of Second Street in 1899. Over 100 years ago, the church site was the headquarters of the Chief Looking Glass band of the Nez Perce Indians. Chief Joseph stayed there. This was originally the Presbyterian church. Joyce Jones Lynn was baptized there. (Courtesy of Judy Ward Karlberg.)

Before the automobile, doctors had to make their house calls in a horse and buggy. However, once the gasoline-powered vehicles were available, many horses were sold, as more and more people started to use cars, which changed transportation for everyone. (Courtesy of the Asotin County Museum.)

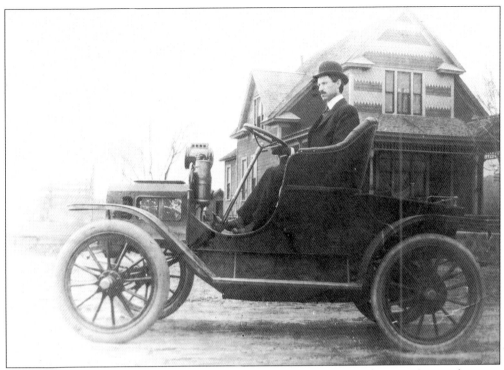

Dr. Paul W. Johnson (1903–1947) is shown here driving his car. He served Asotin County for many years. With a lot of homes in Asotin, along with those in the Theon, Anatone, and Cloverland areas, it was important for the doctor to have a car in order to make house calls. (Courtesy of the Asotin County Museum.)

Joshua and Elizabeth Jones are standing in front of their house in Asotin around 1895. Their children Ann and Estyn (oldest) are with them. Homes built in the area were very strong because of the type of local trees that were used to construct them. (Courtesy of Judy Ward Karlberg.)

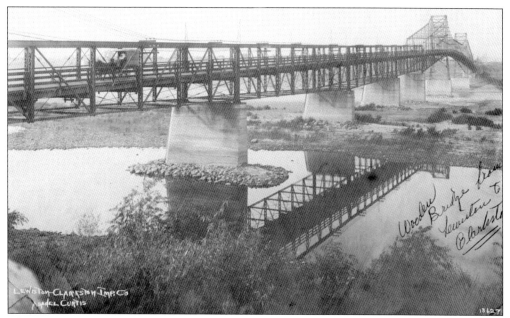

This is the first wooden toll bridge, the Concord Bridge, built June 14, 1899, from Clarkston to Lewiston. Former Asotin resident Gary Hanchett said that Asotin never had a ferry or a bridge, as it did not need one. There were ferries and a bridge just down the road that were convenient to Asotin. (Courtesy of the Asotin County Museum.)

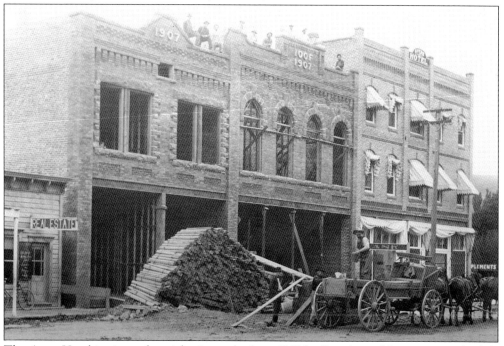

The Ayers Hotel is pictured at right. It was built in 1905 by Ben Ayers. Next to it, on the left, is the Odd Fellows building, constructed in 1907. It was built by Riverside Lodge No. 41. The building adjoining the front was constructed by Eli Bolick in 1907. It was later known as the Marvel Building. (Courtesy of the Asotin County Museum.)

This photograph was taken inside the Ayers Hotel. Ben Ayers, who owned the hotel, is standing at far right. Eventually the Ayers Hotel (built in 1905) replaced the first courthouse, which was destroyed by fire in 1939. It remains the Asotin County Courthouse. (Courtesy of Marian Fredrickson Nelson.)

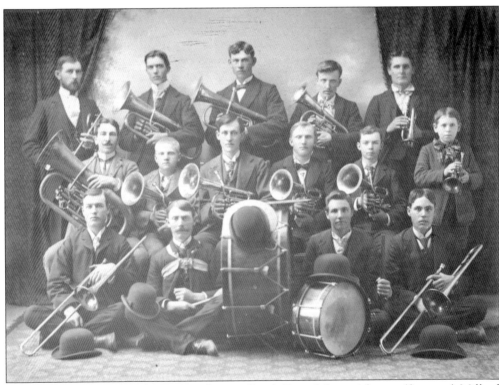

Pictured are members of the Asotin County Band. From left to right are (first row) Millard Johnson, Charlie Taylor, Ed Tate, and Harry Tate; (second row) Louis Closuit, Ed Bucholz, J. Swain, Charlie Bucholz, Mr. O'Keefe, and Mr. O'Keefe; (third row) Mr. Fryzell, Perry Dodson, Ole Green, Charlie Brantner, and Leonard Tate. (Courtesy of Gary Hanchett.)

This veteran was a member of the Petty family. In 1898, during the Spanish-American War, a number of young men from Asotin joined C Company in Pomeroy. They were George Ausman, O.T. Green, Millard Johnson, Charles Brantner, ? Chapman, Bert Dodd, L. Feise, Harry King, Leonard and Harry Tae, and Perry Barnes. (Courtesy of Bruce and Jenny Petty.)

This is the new bridge that replaced the old iron one. Many area families contributed to the building of this bridge. It became the Asotin Memorial Bridge during World War I. Some of the men who went to war did not return, and plaques with their names honoring them were erected on each end of the bridge, (Courtesy of the Asotin County Museum.)

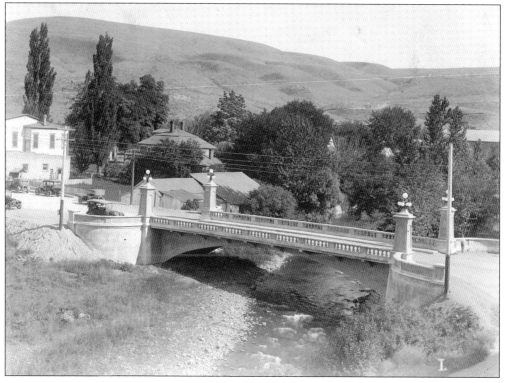

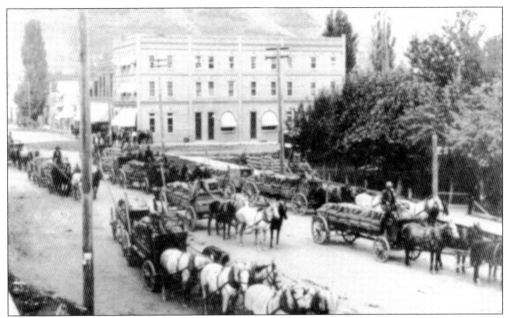

This 1907 photograph, taken by S.J. Sergeant in Asotin on Second Street, shows the teamsters. In the foreground is John Travis, driving a team belonging to Ben Ayers, with Sam Goble in the middle. Behind him is Chad White. Second from the left is Charlie Wilson, and behind him are Pet Patterson and Elmer McGuire. Others are unidentified. The building in the background is the Ayers Hotel. (Courtesy of the Asotin County Museum.)

Former resident Gerry Lloyd's family history goes back three generations to William Ashley of Asotin County: "They helped build the bridge over Asotin Creek and my grandfather's name is on the bridge. Grandfather shot a hole in the stove at an Asotin school declaring school out so he could go fishing. Another time he lost a draft horse to a sturgeon at Buffalo Eddy." Ashley Lane south of the Swallows Nest was named for them. (Courtesy of Gary Hanchett.)

The Fryzell building was a prominent structure on Second and Main Streets in downtown Asotin. It was built in 1895 and housed an opera house, a grocery store, a dry goods store, a jewelry store, a millinery business, a skating rink, and a dance floor. It was demolished in the 1940s. (Courtesy of the Asotin County Museum.)

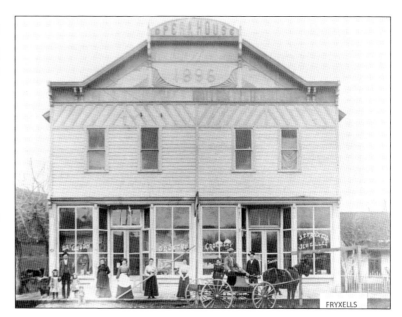

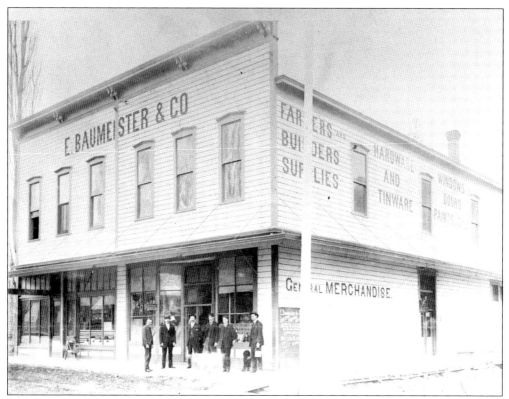

Pictured is Baumeister & Company, a general store and a bank, around 1910. Edward Baumeister was born in Germany in 1848 and came to Asotin in the fall of 1885. He was one of the wealthiest men in the area. (Courtesy of the Asotin County Museum.)

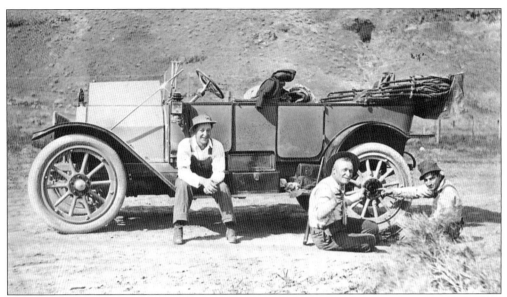

Earl Cooper sits on the running board of a 1912 Abbott Detroit model car. Pictured with him are Leo Ayers and his son Charlie, who was 16 years old. His grandparents Eli and Iva Cooper were early pioneers in 1882. Eli helped build the big ditch that brought water to Clarkston and later operated a livery stable in Asotin. Cooper attended Washington State University and received a degree as a doctor of veterinary medicine. (Courtesy of the Asotin County Museum.)

This is an old gas station on the corner of Second and Fillmore Streets, located across the street from the Asotin County Museum. It was owned by Claudine Tabott Wilson's great-uncle William Anderson, who was also Marla Wilson Doty's great-uncle. The building is gone, but another has taken its place. (Courtesy of Marla Wilson Doty.)

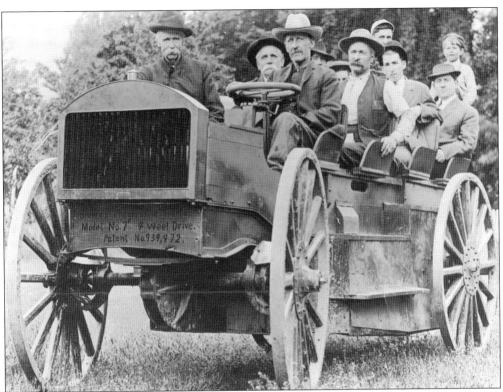

This is an example of the first four-wheel-drive "Michigan" car from about 1905. The Marmon-Herrington Company was founded in 1931 to serve a growing market for moderately priced four-wheel-drive vehicles. The riders and the driver are believed to be from Asotin County. (Courtesy of the Asotin County Museum.)

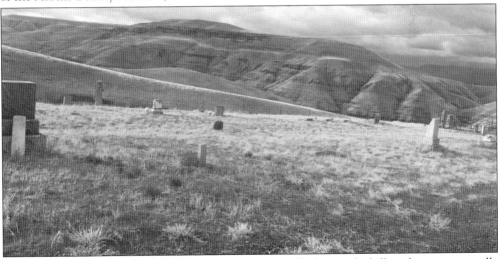

William Critchfield wanted the old cemetery to be moved higher up the hill, and it was eventually accomplished. Decades later, when Chuck Wilson bought the land to build a housing development, he discovered several bodies buried there. It seems when the cemetery was moved to the top of the hill, only the tombstones were relocated. With the original land being Indian territory, Max Halsey said it would not be unusual to find unmarked graves in Asotin. (Author's collection.)

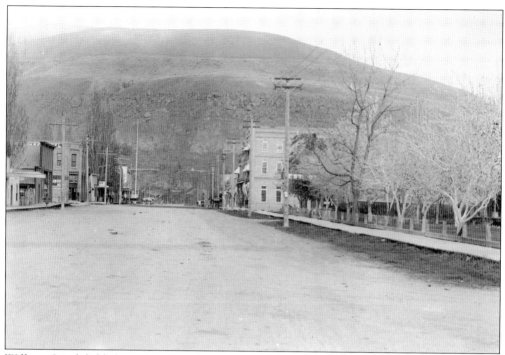

William Critchfield planted poplars along Main Street. He also prepared Asotin Park and fought to have the town cemetery placed in the vicinity of Fourth Street instead of on the hill. A white line is visible on the brink of the hill in this 1916 photograph where the old cemetery was located. Later, it was moved upwards toward Anatone. (Courtesy of the Asotin County Museum.)

This photograph of Gary and Dolly Hanchett, descendants of William Critchfield, was taken on Mother's Day. They grew up in Asotin, and many residents would look out after little Dolly, as she needed special care. They were very protective of her. (Courtesy of Gary Hanchett.)

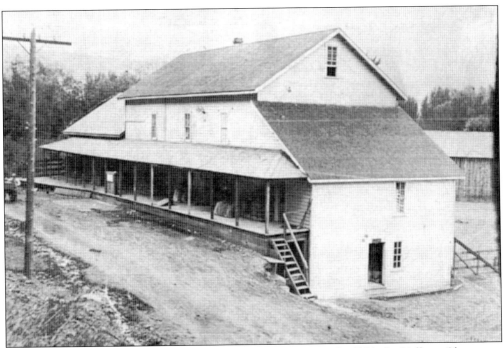

According to Harmer Robeson, this flour mill was built in 1881. In 1934, the Vollmer Clearwater Company sold it to Asotin Roller Mills, and in 1936, it was consolidated into the Jerry Milling Company. The mill produced flour until the mid-1950s. It continued operating, making special mixed grains for feed. In 1962, Robeson turned the mill over to his two sons, Gerald and Jack. In 1974, the mill was sold to Coast Trading, which sold to Marvel Mercantile a few years later. (Courtesy of the Asotin County Museum.)

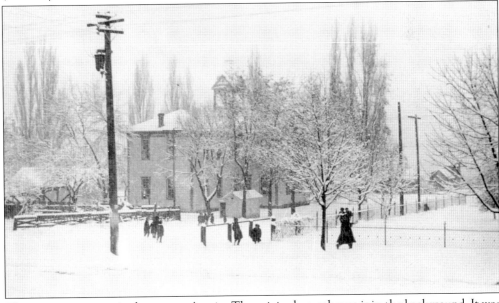

This is a snowy scene in downtown Asotin. The original courthouse is in the background. It was unusual for Asotin to get snow very often; however, Anatone and Cloverland received a lot. The courthouse was built in 1899 and burned in 1936. (Courtesy of the Asotin County Museum.)

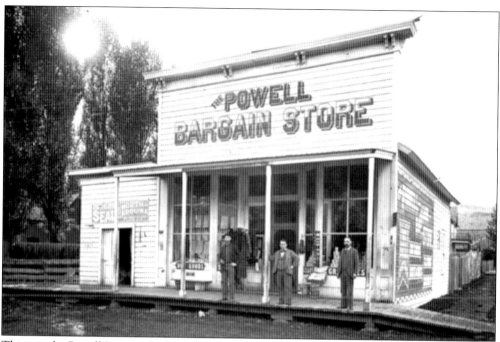

This was the Powell Bargain Store around 1895. It was run by D.O. Powell, pictured at right, along with Jake Rice. Powell was the first merchant to occupy the Wesley Steel Block, which was later known as the Garrison Block. Powell opened his own store in Lewiston around 1902. (Courtesy of the Asotin County Museum.)

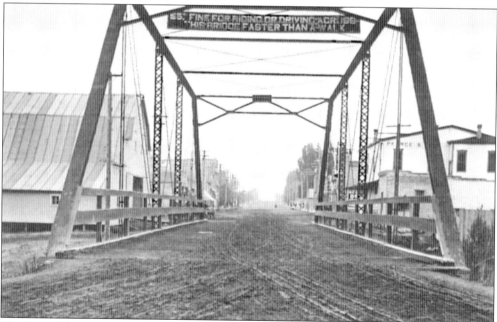

The first public bridge, which crossed Asotin Creek, was built in 1916. It was located northeast of the town, near the Jerry Milling Company. It led to Asotin's Main Street. Later, it was replaced by a stronger cement bridge. The sign reads: "$5 fine for riding or driving across this bridge faster than a walk." (Courtesy of Gary Hanchette)

Four

No Country for Old Men

Anatone, Cloverland, and More

Marian Nelson reminisces about Anatone in the early years: "The first building was the post office. Next was Brown's Grocery store, then next was Steigers repair building, owned by Jim Herrey. They sold clothing, shoes, hardware. Upstairs was a family dwelling as well as room to rent. The other business on the side was another grocery store owned by Charlie Ward. A telephone office and barber shops, and both houses. It was owned by Ray Floch. Next to the barber shop was a trough to water horses. Beyond that was the Crow Hotel and blacksmith shop. There was another store owned by Grey Halverson. They sold most everything. There was also a butcher shop owned by Jimmy Boggan." (Courtesy of the Asotin County Museum.)

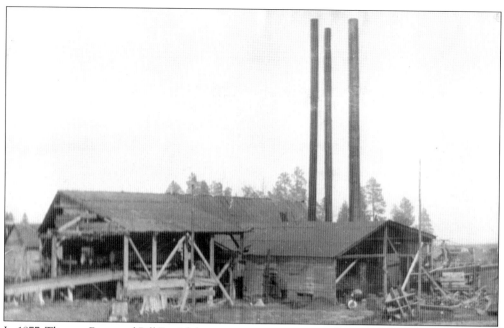

In 1877, Thomas Bean and Bill Farrish became partners in a sawmill. They moved it from Columbia Center to Anatone. The road to town was very dangerous, winding and passing over many hills. The mill was very successful for the settlers. Any excess lumber was sent down the Snake River at Craig and then rafted down to Lewiston. (Courtesy of the Asotin County Museum.)

This is lumber from the Bean/Farrish sawmill located west on Mountain Road. Over 100 years ago, Arthur Farrish purchased the stock, mills, and business of Blue Mountain Lumber and Manufacturing from Thomas Bean, his son-in-law, and became the sole owner. The headquarters were maintained in Asotin. (Courtesy of the Asotin County Museum.)

There was a controversy about how Anatone got its name. The name was proposed by John Dill, one of the early pioneers who had considerable influence and standing among his neighbors. He had said "any town" would suit him, and the place was immediately christened Anatone. A Mr. Packwood stated that Anatone is a city in Greece and that that was where the name came from. A Mr. Isecke was positive that the name came from a squaw who lived in the vicinity of the little town. (Courtesy of the Asotin County Museum.)

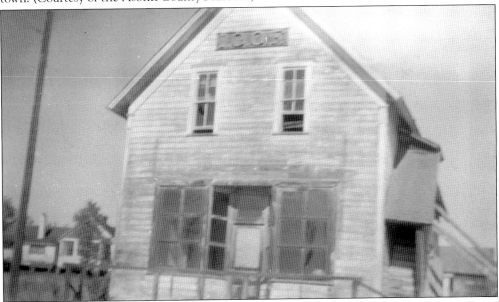

This is the Anatone Odd Fellows Hall and Rebecca Ladies Lodge; the lower level was a dance hall and community center. Many prominent men and ladies were members, including George Ausman, an early arrival to the Asotin area in 1883. He was a schoolteacher and married Grace Farrish. They had six children. He acquired large tracts of Asotin County land. (Courtesy of Marian Fredrickson Nelson.)

Pictured are Marian Fredrickson Nelson and her horse Denver around 1930. Marian was born in Clarkston and raised in Anatone. Her father, Alfred, was a farmer. Her cousins Leon and Matilda Appleford had three girls; later, another one came as a surprise. There was a half mile between their houses on little Millcreek. One of her playmates was Cal Watkins. Marian's father made her a playhouse with homemade cupboards where they all played. (Courtesy of Marian Fredrickson Nelson.)

This is a portrait of the Jack Teague family, Madge, Jack, and Susan, in 1946. Jack was a rancher 15 miles up Asotin Creek for 10 years, where the game reserve is now located. A band of sheep, 1,000 head, came with the ranch, and after two years, he sold the sheep and purchased 200 head of Hereford cattle. (Courtesy of Susan Teague.)

Asotin Creek was noted for having lots of apple trees planted beside it by early pioneer families. These trees attracted many raccoons, and on several occasions, the ranchers got together and went coon hunting. Armed with flashlights and rifles, they would drive down the creek and shoot all the "eyes" out of the trees, then they would all go back to the Teagues' house and have chili and hot chocolate. (Courtesy of Susan Teague.)

During Prohibition in the 1920s and early 1930s in the rugged, remote parts of Asotin County, many of those were who raised in the area made moonshine or knew the location of various stills. According to Abe Wilson, his father, Charlie, was run out of town by the sheriff, Wayne Bezona, and he went to Arizona and ended up making moonshine for Al Capone. (Courtesy of Asotin County Museum.)

Alfred O. Hendrickson is shown getting ready to round up some of his cattle at his ranch in Anatone. His daughter, Marian Fredrickson Nelson, remembers a little gelding called Denver. Their relatives, the Applefords, had a horse named Brownie, and they rode her loaded with kids to the tail. (Courtesy of Marian Fredrickson Nelson.)

This is the Hendrickson ranch in Anatone. Theon was a little town nearby, and it wanted to be the county seat but needed water to be considered. At one time there was a little pond near Theon and the water was piped into it from Mill Creek. However, Asotin became the county seat instead. (Courtesy of Marian Fredrickson Nelson.)

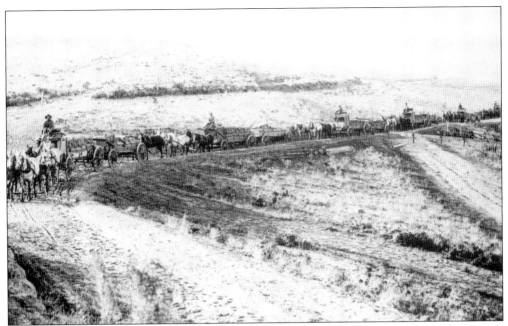

Pictured here are all the farmers coming together for harvest. Ranchers pictured are Lee Lynch from Cloverland, Rufus Ward from the Bolick Ranch, John Travis from Ayers Ranch, Elmer Goble from the McIntosh K. Ranch, John Sprause from the Sangster Ranch, and John Keiber from the D. McIntosh Ranch. (Courtesy of Gary Hanchett.)

Joy Lynn Ward's home on Montgomery Ridge is pictured here. It was the original home of her parents, Adelia and Estyn Jones. Her grandparents were Ringold and Kate Stone. She married Lester Ward of Anatone on September 27, 1940. They had one child, Judy Ward Karlberg. (Courtesy of Judy Ward Karlberg.)

Pictured here are some friends from Anatone who were neighbors with Marian Fredrickson Nelson. From left to right are Billie Hollenbeck, Marian Nelson, Bill Wilson, unidentified, Pat Spickard, Carl and Jo Hendrickson, and Jack and Phyllis Hollenbeck. (Courtesy of Marian Fredrickson Nelson.)

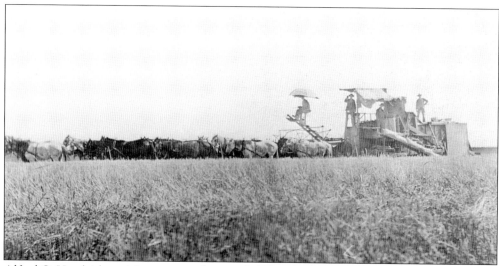

Alfred O. Hendrickson is harvesting wheat with 27 head of horses pulling the combine. Usually 32 head were needed to pull a 14-foot machine. The combine is a machine that cuts 14 feet in one swath. These great teams of horses were driven by one man, who was seated in an extension frame over the wheel team. (Courtesy of Marian Fredrickson Nelson.)

Marian Henderickson Nelson is singing with Jack King's Orchestra in Washington, DC, in 1943. She loved to sing. Prior to that, she went to college for one year. In 1941, World War II broke out, and she left the area when she was 18 years old and moved to Washington, DC. She lived in an old mansion with other gals. She worked for the government at the Pentagon in Strategic Services. A job opened, and she became the receptionist for James Grafton Rogers, who is in *Who's Who in America*. It was a feather in her cap. (Courtesy of Marian Fredrickson Nelson.)

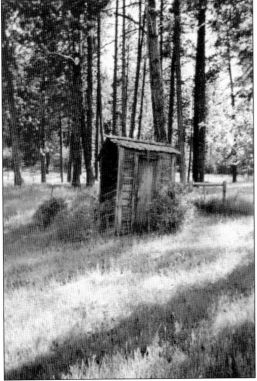

This is an old outhouse on the Laurence Hamilton Ranch. This area also had the first public park, and this was where people came to celebrate the Fourth of July. It was a pioneer tradition to plant hollyhocks around one's outhouse as a courtesy to protect the modesty of lady visitors to one's home. This allowed the lady guests to discreetly locate the outhouse without disclosing their need to use the facility. They simply stepped outside and looked for the hollyhocks. (Courtesy of Marian Fredrickson Nelson.)

This was one of the first pictures taken on the Teague Ranch up Asotin Creek in 1946. From left to right are (first row) Karen Brown (cousin of the Teagues), Susan Teague, and Marilyn Gordon; (second row) Cleo Gordon, Johnnie Carney (sister-in-law to a Mrs. Teague), Jack Teague, Madge Teague, Glenn Brown (brother-in-law to Madge Teague), and son Jerry Brown and wife Nina Brown (sister to Madge Teague). (Courtesy of Susan Teague.)

This photograph of the Stone family was taken around 1921. From left to right are (first row) Ray Hostettler, Elmer and Iva McGee, June McGee, Claude and Winifred Tabot, Cress and Ella Stone, Goldie Stone, and Kate and Ringold Stone; (second row) Harve Hostettler, Esther and Bill Anderson, Burton Tabot, Elaine Tabot, Claudine Tabot, Jake Stone, Myrtle Hostettler, Fae Hostettler, and Melva and Clarence Brumpton. (Courtesy of Judy Ward Karlberg.)

Janet Halsey and Sally Halsey are feeding chickens on the family ranch in the 1940s. Pioneer E.E. Halsey was a representative of Clarkston and served three consecutive terms. He was an able public servant, and during his time in office, he put Asotin County on the map in Olympia. (Courtesy of Janet Halsey.)

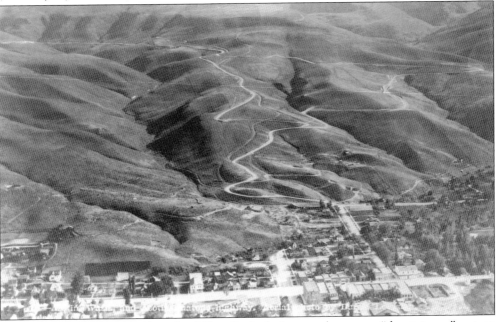

The original grade to the Cloverland Flat climbed what was known as "the stairway," a steep earth-covered incline in a gap that went straight up over the hill. Wagons and teams literally had to slide down the grades on the descent. During muddy seasons, the Anatone Stage required two four-horse teams for the trip up the hill. A fresh team had to replace the worn out horses at halfway stations. (Courtesy of the Asotin County Museum.)

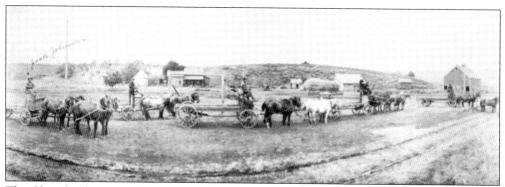

The Cloverland area was first populated in the early 1900s with the hope of starting orchards and growing other crops. These attempts failed, leaving Cloverland to those who could make a living raising livestock and grain. Asotin County rancher George Ausman owned a large ranch that reached from Ten-Mile on the Snake River to far up on Weissenfels Ridge. (Courtesy of Bruce and Jenny Petty.)

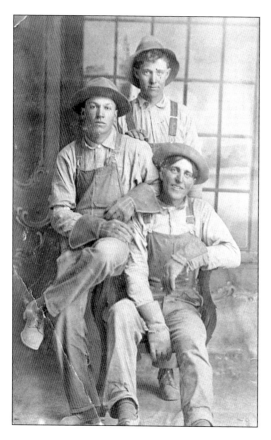

Pictured from top to bottom are Tom Johnson, Wilbur Petty, and Howard Howell. In 1974, Ralph Petty was named Asotin County Cattleman of the Year. (Courtesy of Bruce and Jenny Petty.)

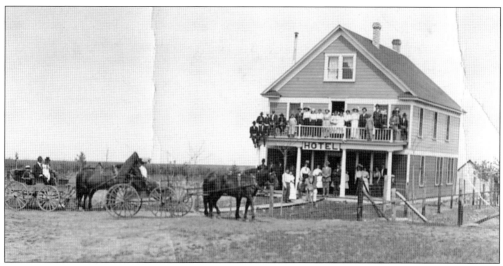

The Cloverland Hotel is pictured on May 28, 1811. At its peak in 1910, Cloverland had a population of 400. Today, very few buildings remain. One structure is the garage building, which was first a store and then converted to a garage in 1918. The owner of the garage was trained in automotive repair and opened the only auto dealership in the area. Near the garage is a church and the Cloverland cemetery. (Courtesy of Bruce and Jenny Petty.)

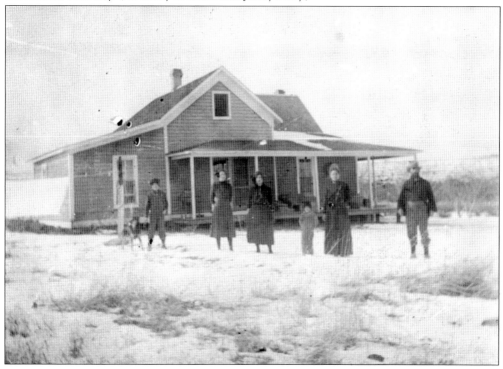

John and Mary Petty built a house on their new homestead about a quarter mile up the draw from the present home of Bruce and Jenny Petty. John had a dream that one of the Cloverland lakes burst its levy and washed them out in the middle of the night, so they spent one summer moving their house over to where Tom and Vicki Petty lived. They later moved it to Asotin on Second Street. (Courtesy of Bruce and Jenny Petty.)

April 26, 1960, was the day the Pettys tipped over a cattle truck. It was loaded with yearling calves from Pasco. Dale started to get stuck, and Ernest told him to step on the gas; the truck tipped. The occupants of the truck had to crawl out the window, and the calves walked to the barn. The only damage was a broken mirror. (Courtesy of Bruce and Jenny Petty.)

In Cloverland in the fall of 1955, the Pettys got four nice bucks. Hunting is a tradition in Asotin County. Deer meat is delicious and supplements meals. In October 1946, John Ewing of Clarkston Heights shot down a 200-pound cougar while hunting on the hogback near Cloverland. Today, the area is a draw for hunters and trappers. (Courtesy of Bruce and Jenny Petty.)

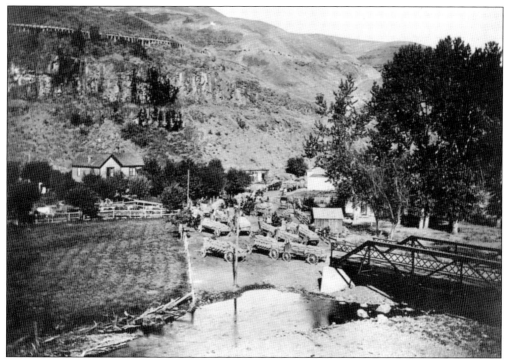

Cloverland farmers are shown taking wagonloads of wheat to town to be sold and put on boats to be sent down the river. On the way home, the farmers would stay at the Jerry Hotel and get an early start in the morning. (Courtesy of Asotin County Museum.)

This was Joy Marie Lynn and Lester Ward's first home on Asotin Flat. Later, they moved to Clarkston. They worked for Onstots. She and Lester were married in Anatone on September 27, 1940. A daughter, Judy Ward, was born in November 1943. (Courtesy of Judy Ward Karlberg.)

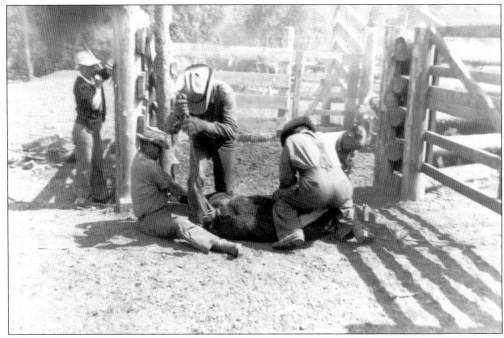

This photograph was taken on the Teague Ranch in 1953. From left to right branding the calf are Elaine Adley, Harry Baker (hired man), Jack Teague, an unidentified man with his back to camera, and Byer Adley at the head of the calf. (Courtesy of Susan Teague.)

Pictured are Orville and Pearl Appleford and their granddaughter Edna Graham Webber. The main industry of the area was raising grain crops like wheat and barley. Most of the ranches also raised some livestock, mainly cattle. (Courtesy of Wally Graham.)

Rush Parsons is shown with his wife, Callie, and sister Myrtle. (Rush is C.T. Parsons's half brother.) C.T. homesteaded in 1900 in Cloverland with his brother. When homesteaders came to Cloverland, they thought there was an aquifer under the ground, so they planted lots of fruit orchards. However, after time, all the trees died out because the water went dry. (Courtesy of Quinten Parsons.)

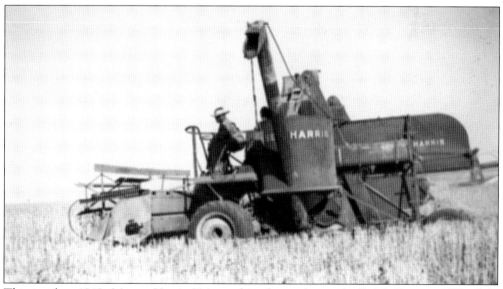

This is a late 1940s Massey Harris 21A combine being driving by Ralph Petty in 1951 while harvesting in Cloverland. Thanks to machines, harvesting, which formerly required a large crew and many work hours, was reduced to a simple operation. (Courtesy of Bruce and Jenny Petty.)

On New Grade to Grande Ronde. West Branch Rattlesnake
Crippen

William H. Boggan was one of the progressive and prominent farmers in the community. In 1880, Major Boggan was chosen justice of the peace, being the first officer of this kind in the community. He held the office for 18 years. He married Ida J. Enyart, and they had three children. (Courtesy of Gary Hanchett.)

William Fordyce purchased a tract of land in Asotin Creek in 1900. In addition to having orchards, he raised horses and sheep and was a very prosperous man. From left to right are Aaron Lincoln Fordyce, Marian L. Hendrickson, and Matilda Ann Beauchamp Fordyce posing in their orchard in Anatone. Matilda Ann came from Missouri in 1845 in a covered wagon on the Oregon Trail as a 10-year-old. She lived to be 99 years old. She is buried in the Asotin Cemetery. (Courtesy of Marian Fredrickson Nelson.)

Alfred Fredrickson is milking cows on his family ranch in Mill Creek Canyon near Anatone. Marian Nelson recalls that "they built many barns and machine sheds that dotted the landscape." She also said that there were "not a lot of trees, just the mountains." (Courtesy of Marian Fredrickson Nelson.)

The first settlers came to Cloverland Flat in the late 1870s and early 1880s. The first post office was established April 2, 1883, and existed until Mary 14, 1904. The Cloverland Post Office was established February 26, 1903, and operated until July 28, 1942. The Cloverland area is now a mail route out of Asotin. (Courtesy of Quinten Parsons.)

This a picture of Gary Floch when he was about two years old in 1942, helping out on the ranch. The Floch families in Asotin County are descendents of Johannes Peter Floch. (Courtesy of Gary Floch.)

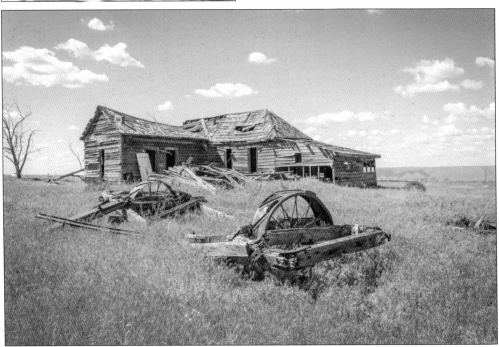

This is what the Hostetlers' house in Cloverland looks like today. Although Anatone and other small towns are considered ghost towns, Cloverland still has farmers and ranchers. (Courtesy of Marcia Darby.)

The town of Cloverland was platted March 11, 1902, by the Asotin Land and Irrigation Company. Numerous homes were built in 1902 and 1903. It soon had a good general store, a post office, a blacksmith shop, a schoolhouse, and two churches. (Courtesy of Jenny and Bruce Petty.)

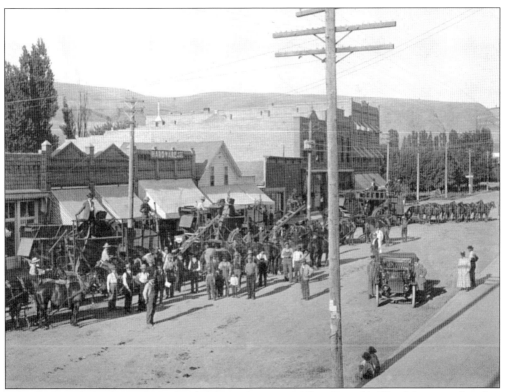

A load of rough lumber is being hauled from Anatone Mill to Farrish's Blue Mountain Lumber Company on Main Street in Asotin, where it would be planed and finished. Note the tandem wagon with eight horses. (Courtesy of the Asotin County Museum.)

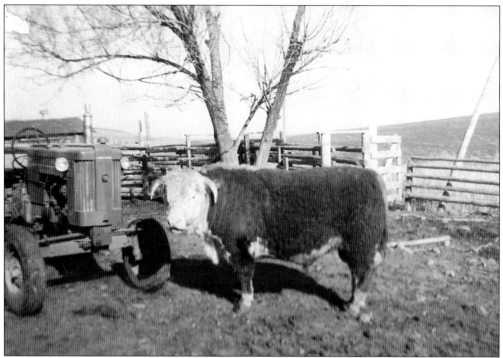

This photograph taken in Cloverland shows a Hereford bull, which was bought in Missoula in 1958. He was first in his class. The Petty family paid $635 for him. Cloverland settlers were cattlemen as well as farmers. (Courtesy of Bruce and Jenny Petty.)

Ted and Dick Petty are having a Huckleberry party. They used their imaginations and made moustaches out of moss. (Courtesy of Bruce and Jenny Petty.)

This photograph of the Pettys' jeep shows the abundance of their hunting trips in the area. For years, the people of Cloverland have hunted and fished to supplement their food supply. Today, one needs a license to hunt; before, a person could just go out their back door and get something for dinner. (Courtesy of Bruce and Jenny Petty.)

The Halsey family is pictured here at Christmas. From left to right are Marie, Janet, Wallace (Wally), and Sally. Marie and Wally are gone now, but Sally and Janet live in Clarkston. Marie was very talented. She taught piano and music appreciation at the Asotin grade school, and Wally was a horse-and-cattle man. (Courtesy of Janet Halsey McCoy.)

The three Floch sisters (Benjamin Floch's daughters) pictured at left are, from left to right, Fern Floch Forgy, Lillian Floch Chandler, and Neva Floch Sangster. When Benjamin Floch was born on September 6, 1855, his father, Christian, was 44 and his mother, Rhoda, was 38. He married Mary Corella Harbin and they had nine children together. He then married Nellie Rusk on March 30, 1911. He died on May 1, 1927, in Lewiston, Idaho, at the age of 71, and was buried in Anatone. Pictured above from left to right are Neva Floch Sangster, Fern Floch Forgey, and Lillian Floch Chandler together again in 1965. Neva was married to Carl Sangster and they lived in Anatone. (Both, courtesy of Gary Floch.)

Five

TRUE GRIT

DISASTERS, HANGINGS, FLOODS, AND THE CHINESE MASSACRE

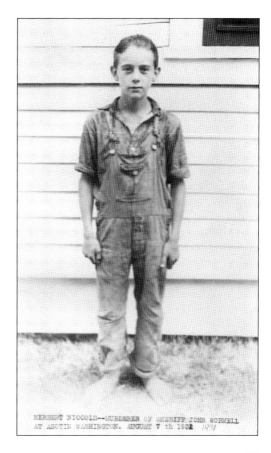

On August 5, 1931, a 12-year-old boy shot and killed Asotin County sheriff John Wormell. The sheriff was killed at 1:15 a.m. after he and a deputy responded to a report of a burglary in a store at the intersection of Second and Cleveland Streets. (Courtesy of the Asotin County Museum.)

HERBERT NICCOLS—MURDERER OF SHERIFF JOHN WORMELL AT ASOTIN WASHINGTON. AUGUST 7 th 1931

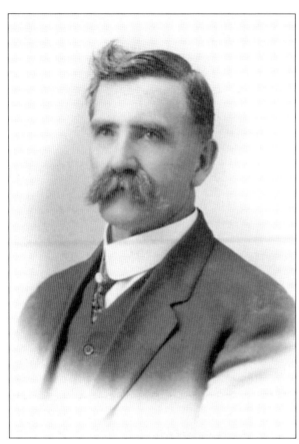

The store owner had opened the door to the store, and he and the sheriff entered. As Sheriff Wormell (pictured) passed by a barrel, the suspect, 12-year-old Herbert Niccolls Jr., was hiding behind it. Niccolls fired a single shot from a .32 caliber pistol he had previously stolen. The other deputy then took the boy into custody. (Courtesy of the Asotin County Museum.)

Local resident Abe Wilson, now age 91, was seven years old at the time of the shooting. He remembers he went to the store after it happened, but no one was allowed in. Wilson said "the boy was a nice kid—he lived with the Watkins—on First Street. He was hungry and had a gun, had dinner, and then went and broke into the store. Herbert was down by the counter when the sheriff came in and the kid was trying to scare him and accidently hit the sheriff in the head." (Courtesy of Abe Wilson.)

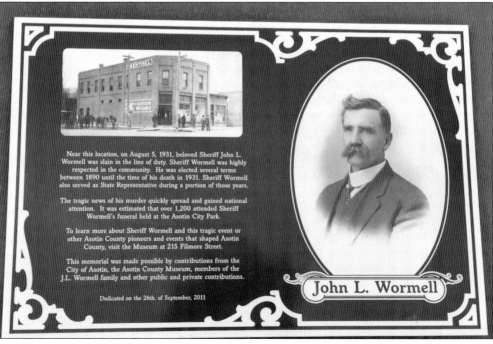

Near this location, on August 5, 1931, beloved Sheriff John L. Wormell was slain in the line of duty. Sheriff Wormell was highly respected in the community. He was elected several terms between 1890 until the time of his death in 1931. Sheriff Wormell also served as State Representative during a portion of those years.

The tragic news of his murder quickly spread and gained national attention. It was estimated that over 1,200 attended Sheriff Wormell's funeral held at the Asotin City Park.

To learn more about Sheriff Wormell and this tragic event or other Asotin County pioneers and events that shaped Asotin County, visit the Museum at 215 Filmore Street.

This memorial was made possible by contributions from the City of Asotin, the Asotin County Museum, members of the J.L. Wormell family and other public and private contributions.

Dedicated on the 26th. of September, 2011

John L. Wormell

Ninety-one-year-old Max Halsey remembers playing with Niccolls as a young boy. Niccolls was held at the Pomeroy jail while his trial was held in Asotin. Older generations of the Bezona, Halsey, and Hostetler families were involved in the trial. Fr. E.J. Flanagan, the founder of Boys Town, made a nationwide appeal for Niccolls's "parole" to Boys Town. It did not happen, though Niccolls reformed in prison and was paroled in 1941. (Photograph by author.)

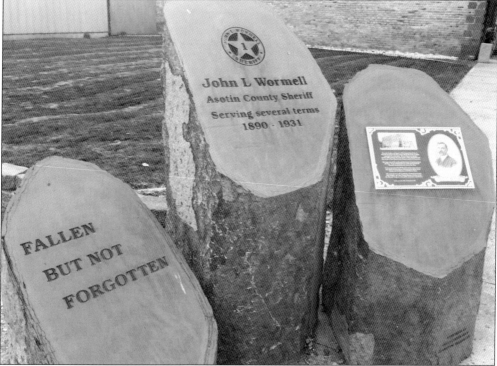

This event caused Asotin County to be thrust into the national spotlight because Herbert Niccolls was convicted of first degree murder and sentenced to life in prison at Walla Walla State Prison. People were outraged that they would sentence a 12-year-old boy to life in prison, but that was the sentence at the time for first degree murder. He was pardoned by the governor at the request of Father Flannigan of Boys Town after serving 10 years. Sheriff Wormell was 73 at the time of his death. His funeral was held in Asotin Park and attended by 1,500 mourners. He was buried in Anatone. Sheriff Wormell had served with the Asotin County Sheriff's Department for 35 years and also served as an elected representative to the state legislature. He was survived by his wife, three sons, and a daughter. (Photograph by author.)

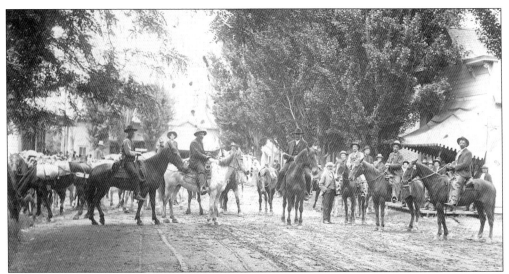

On August 3, 1903, twelve-year-old Mabel Richard was lost while the family camped in the mountains near Farrish's sawmill, close to Anatone. She was killed by 26-year-old Will Hamilton, a rancher who lived six miles southeast of Anatone. He tried to rape her and then choked her. He was later arrested. On August 5, 1903, a squad of 16 masked men marched into the jail and secured the prisoner. They took him to First and Fillmore Streets. A rope was thrown over an electric light guy wire, and the body was raised four feet. One of the masked men was believed to be James Norfleet Boggan of Anatone. No one was ever arrested, as lynchings were common at that time. (Courtesy of the Asotin County Museum.)

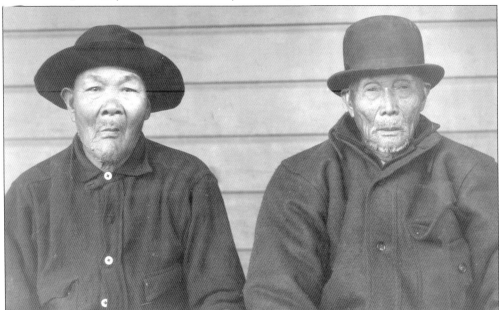

In 1887, there was a massacre of as many as 34 Chinese gold miners. The killers were believed to be a gang of Oregon horse thieves, ranch hands, and a 15-year-old schoolboy. Their crime was discovered when the mutilated bodies of the Chinese miners—the killers apparently hacked their victims with axes after they were dead—began showing up 65 miles downstream, past Asotin to Lewiston, Idaho. (Courtesy of the Nez Perce Historical Society.)

The large barn on the left belonged to Walt and Loretta Waffle, parents of Teri Waffle McGuire and Clint, Lori (Atchley), and Lisa Waffle. The Waffles moved to Asotin around 1970, just before a flood. Here, a bridge is floating downriver during a flood. There also used to be two lakes up Charlie Creek that washed out at that time, increasing the flood. (Courtesy of Ken Powe.)

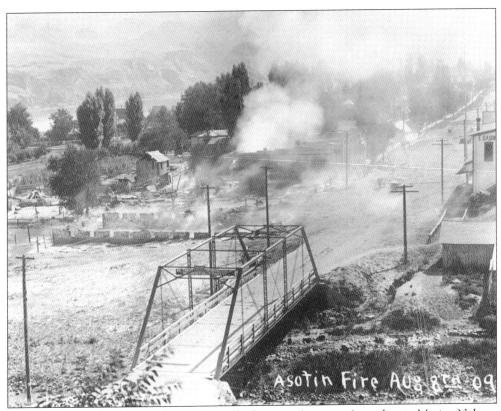

There were a couple of fires in Asotin, but no bad ones in Anatone. According to Marian Nelson, "The old blacksmith, Maury, their house burned down. The old church burned in the forties. Did we have floods? No. The only thing was the deep snowdrifts in those days. Now, Asotin doesn't have the snow like that." (Courtesy of the Asotin County Museum.)

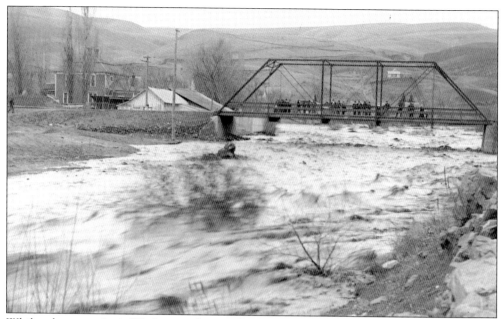

While other counties in Washington have suffered immense losses by fire, it appears that citizens of Asotin were to be sorely tried by deluges of water. On Thursday afternoon, May 20, 1897, Asotin was the scene of desolation and destruction. A wave of water 15 feet in height passed through, sweeping everything from its path, destroying homes and farms, drowning stock, and leaving ruin in its wake. (Courtesy of Gary Hanchett.)

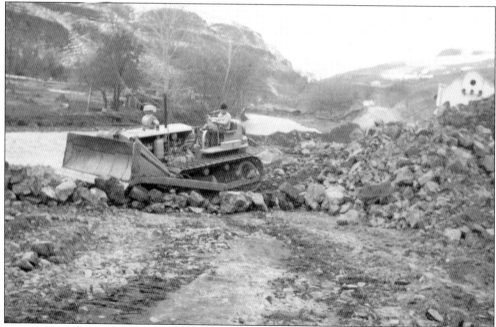

A bulldozer was busy on Asotin Creek in 1965. The flooding in Asotin deposited so much gravel in the creek's old channels that it carved a new path. Asotin Park was not so fortunate. The creek spread into the park, filling picnic shelters with debris, destroying playground equipment, and leaving boulders in its wake. (Courtesy of Ken Powe.)

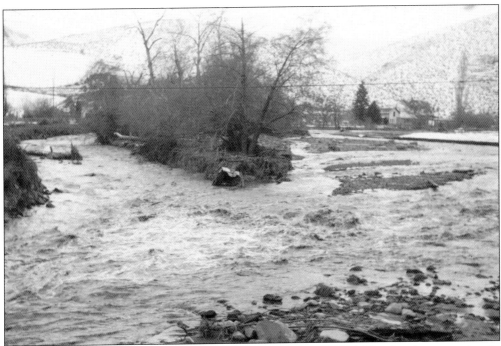

The worst flooding in Asotin Country occurred on February 7, 1996. Flooding began on Asotin Creek, as well as along the Grande Ronde River, which is in extreme southeastern Asotin County, and into the town of Asotin. By Saturday, February 10, the rain had stopped, and the floodwaters retreated quickly. Property damage ran into the millions of dollars. Fortunately, no lives were lost. This photograph was taken around 1973. (Courtesy of Ken Powe.)

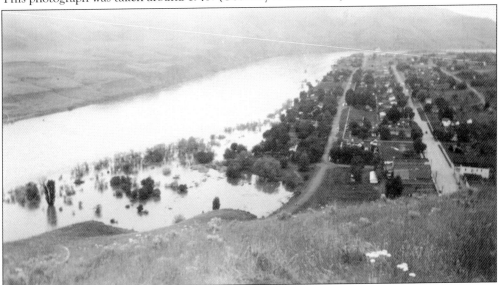

Asotin Creek flooded over the top of its levee. The creek threatened two homes and actually flowed into the city's sewer system. High school students prevented further damage by stacking up sandbags. The most damaging floods were in 1974 and February 1996. Eunice Halsey had a farm that got swallowed up when the dam collapsed. This photograph was taken around 1973. (Courtesy of the Asotin County Museum.)

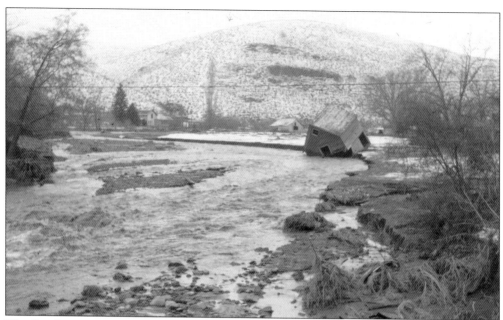

The flooding in Asotin was caused by near record warmth in the mountains and the valley. Asotin was hardest hit when quick runoff sent creeks on the rampage. The broken barn seen here belonged to the Hough family. Cow carcasses were floating down the river. The American Red Cross declared Asotin County a disaster. The creek reached its peak shortly before 3:00 p.m. on February 7, 1996. This photograph was taken around 1973. (Courtesy of Ken Powe.)

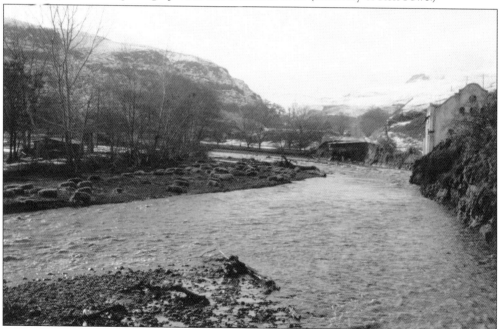

A number of roads to ranches farther up Asotin Creek tributaries were closed by debris or washed out. According to the Asotin County Housing Authority, 10 families and 32 people could not return to their homes and ranches for a few days. Asotin's old Memorial Bridge, just below the city park, was still standing. This photograph was taken around 1973. (Courtesy of Ken Powe.)

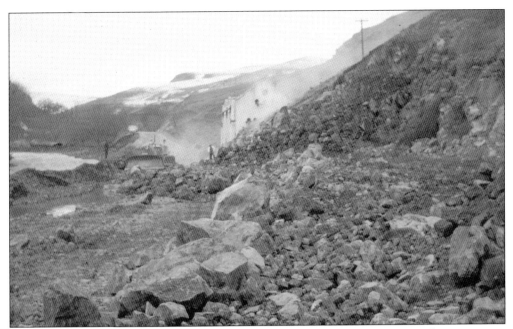

There used to be two lakes up Charlie Creek that washed out at the same time, thus increasing the flood. A man who lived on Meader Street in Asotin operated bulldozers in the 1960s. He would dam up the creek under the bridge at the park to make a swimming pool for the kids. This photograph of flood damage was taken around 1973. (Courtesy of Ken Powe.)

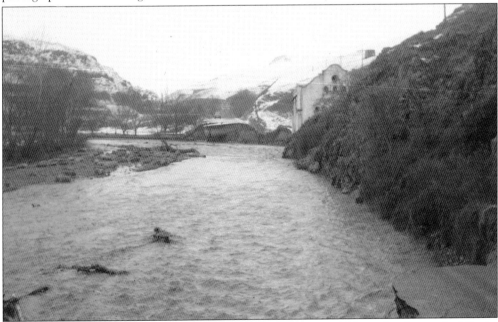

One local resident, Dr. William Bond, told the *Lewiston Morning Tribune* that he watched Snake River Road as it crumbled into the Grande Ronde River. The *Tribune* reported that Bond had lost 50 pigs and 300 piglets from his ranch to the flood, but Bond was not thinking about evacuating. "We can always climb the mountain if we have to," he said. This photograph was taken around 1973. (Courtesy of Ken Powe.)

In 1936, a fire destroyed the original Asotin County Courthouse, built in 1899. After arson was deemed the cause, speculation circulated that Clarkston citizens who wanted the county seat in Clarkston were behind the fire. Meanwhile, community leaders in Clarkston seized the opportunity to reignite the campaign to take the county seat, and the issue was again put to the voters in November 1936. Although the margin had widened significantly since 1916, with 1,951 votes favoring Clarkston to 1,291 cast for Asotin, the three-fifths rule kept the county seat out of reach for Clarkston once again. A mere eight additional votes were all that Clarkston needed. (Courtesy of the Asotin County Museum.)

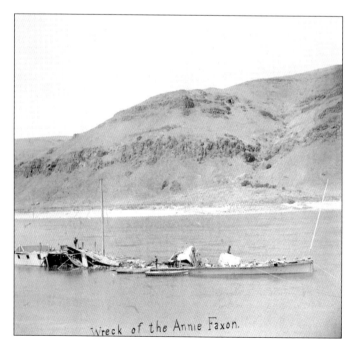

Wreck of the Annie Faxon.

The explosion and wreck of the steamer *Annie Faxon* occurred on August 4, 1893, in the vicinity of Almetta. The boat, carrying 23 people including crew, drew near shore, and the boiler exploded without warning. The sides of the boat were blown out, and the cabins and the pilot house came down with a crash. The crew and passengers were thrown into the stream. Some were scalded, others crushed under falling objects. The boat sank 40 feet from shore. Eight people were killed, and only four escaped without injury. (Courtesy of Gary Hanchett.)

Six

LITTLE HOUSE
ON THE PRAIRIE
SCHOOLS, LODGES, AND POST OFFICES

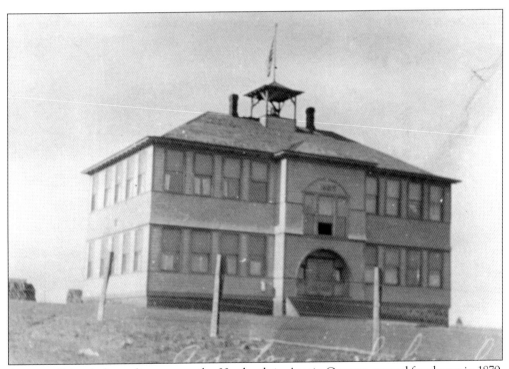

Anatone School, the earliest among the 33 schools in Asotin County, opened for classes in 1879, four years before the county was formed. Angie Bean, later the first county school superintendent and better known as Mrs. John O. Tuttle, was the teacher. Two buildings were erected in 1907. By 1918, four wagons were contracted to pick up the children, and indoor chemical toilets were installed in the buildings. (Courtesy of the Asotin County Museum.)

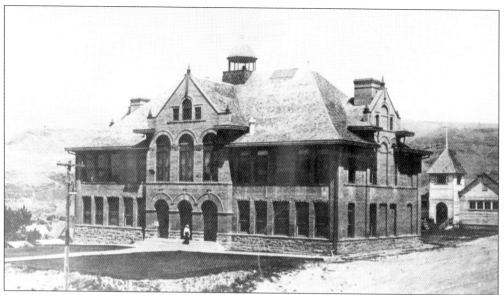

This is Asotin High School under construction in 1909. The old brick schoolhouse and the district school building behind are long gone. Marge Lynch later built a big mansion where the schoolhouse once sat. (Courtesy of Gary Hanchett.)

Pictured around 1906 are, from left to right, (sitting) Racie Bowersock, coach Reed Fulton of Asotin, coach Chest Green, and Margaret Taplin; (standing) Theo Hamilton, Susie Strukey, Marjorie Sangster, Mary Bowersock, Ernestine Fine, Velma Green, and Stella Hamilton. The Anatone summer basketball team played the team from Montgomery Ridge each Fourth of July. (Courtesy of the Asotin County Museum.)

Asotin was reported to have one of the best school systems in the county. The classes were small, and the teachers were excellent, imparting their knowledge to their young wards. At that time, the teacher's word was law, and students did their best to adhere to it. The old butcher shop was used for classrooms. (Courtesy of the Asotin County Museum.)

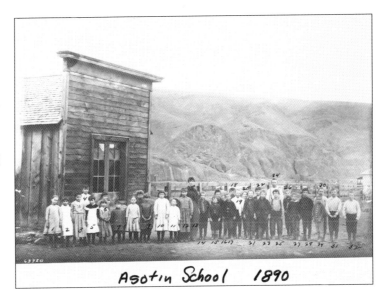

Asotin School 1890

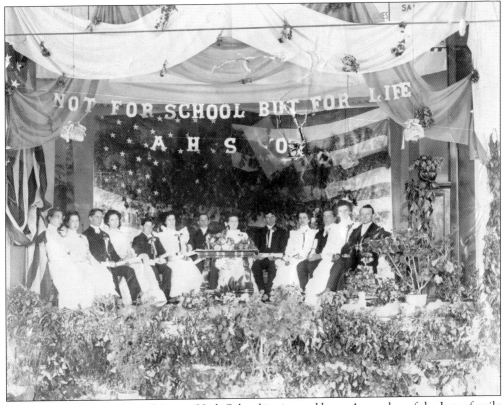

The 1903 graduating class of Asotin High School is pictured here. A member of the Jones family was in this class. (Courtesy of Judy Ward Karlberg.)

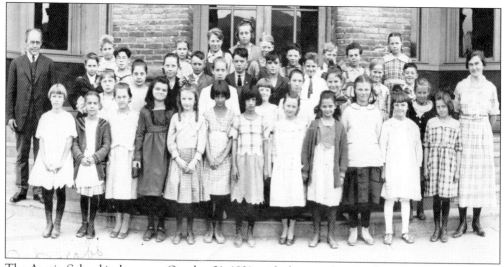

The Asotin School is shown on October 21, 1921, with their teacher, Professor Jacobs. Among the students are Theodore Graham, Ralph Englehorn, Howard Arledge, Della Shoal, Frank Pitsford, Allen Hayworth, Kermit Beckman, Willie Hooker, Frieda Hulse, Velma Montgomery, Alice Vance, Ross Olson, Helen Berry, Beryl Sampson, Lewis Tiffany, Conrad, Helen Spoffard, Ina Corwell, Gray Pankey, Birdelia Cloniger, Irene Rowland, Gern Baughman, Lillian Schweiter, Etoile Cook, Maxine Steeir, Mable Miller, Millie Miller, Odna Evans, Louise Fisher, Juanita Lanz, Mary Alice McIntosh, and Della Miller. (Courtesy of Gary Hanchette.)

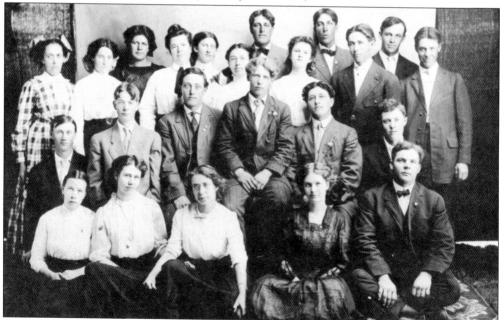

A Cloverland Sunday school class is pictured here. From left to right are (first row) Nellie McMilean, Jennie Mitchell, Ruth Morrow, Annie Weaver, and Frank Larene; (second row) Clearly Mitchell, Clyde Morrow, Lester Reever, Virgil Roberts, Lorinie Weaver, and Howard Howell; (third row) Martha Hodges, Pearl Case, Virginia Parsons, unidentified, Mary Vargo, Bert Morrow, and Roy Horro; (fourth row) Lil Johnson, Tom Johnson, Frank Johnson, and Mitchell ?. The photograph was taken by Charly Brantner. (Courtesy of the Asotin County Museum.)

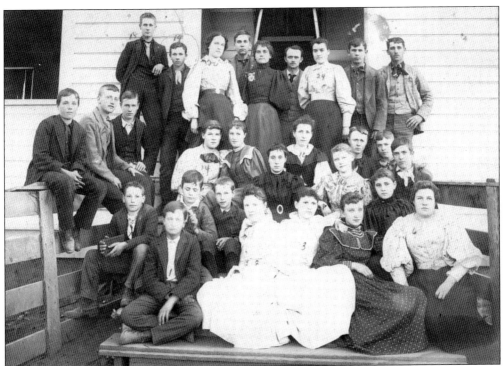

This Asotin School photograph was taken around 1896. The students are Henry Howard, Belle Critchfield, Little Cora Meadar, Maude Rice, Maude Bingham, Lil Wamsley, Elton Rice, Hal Wann, Frank Critchfield, Fannie Anderson, Anna Crimson, Myrtle Pitt, Maude Wann, Grace Farrish, Millard Johnson, Charlie Brantner, Harry Tate, Leonard Tate, Marcus Forgery, Mable Waldrup, Arthur Farrish, Lena Wormell, J.G. Jones (teacher), ? Brooks, Frank Weshide, Doc Morrow, Walter Jones, Freddie Rogers, and Will Fulton. (Courtesy of Gary Hanchett.)

Two buildings were part of the Anatone School in 1907. The barn-like structure at right was the gymnasium-auditorium. Altus Hall had a barn on the property, and the fathers would visit, eat their sack lunches, and wait for the kids to get out of school. They did not have buses, just a wagon pulled by horses and a sleigh for the winter. (Courtesy of the Asotin County Museum.)

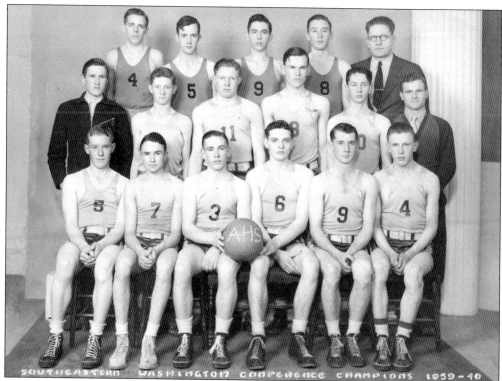

This is the Anatone basketball team around 1939. Glen Hough, Don Floch, Jim Sangster, Ken Hollenbeck, and Bryon Ward were some of the players; the rest are unidentified. The other teams hated to play the farm boys because they were tough. At Anatone, students were more of a big family than a school. Everyone studied together, played together, and rode buses together. (Courtesy of Marian Frederickson Nelson.)

Clarkston's school system dates from 1897, starting in a room in a private home. This photograph shows the first school building in Clarkston, in 1898. The building was located on the corner of Thirteenth and Chestnut Streets and later destroyed by fire. (Courtesy of the Asotin County Museum.)

Seven

THE DAY OF THE COWBOYS
ASOTIN COUNTY RODEO AND FAIR

The first Asotin County Fair was started on May 5, 1939. A group of Asotin citizens decided a spring festival of some type should be created. Many businessmen were against it, but many more were for it. The elected officers were David Grewe, president; Esther Anderson, secretary; and Earl Cooper, treasurer. (Courtesy of the Asotin County Museum.)

The displays, food, crafts, and exhibits in the fair building, including commercial display, plus those outdoors, have continued to improve through the years. The parade was always a big draw. Crowds continue to converge on the town during the last weekend of April. (Courtesy of the Asotin County Museum.)

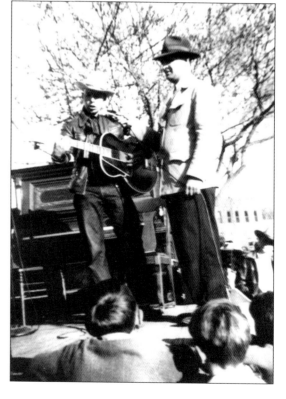

The first Asotin County Rodeo and Fair was held on Main Street in Asotin. Local residents are shown here—Gifford Bott is playing guitar, Chalesy Floch is holding a microphone, and Frank Snyder is standing by a truck. (Courtesy of the Asotin County Museum.)

In 1939, Delano Hirzel, shown riding a Shetland pony, led the parade down Main Street in the afternoon. Mayor Joe Forgery (on horseback) and members of the city council followed. Next in line was the Clarkston High School band, under the direction of Vernon Wiscarson. (Courtesy of the Asotin County Museum.)

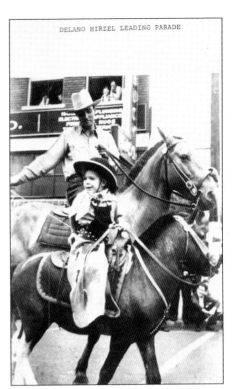

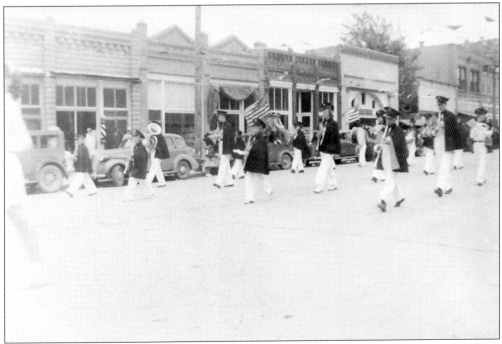

The fair had a festival atmosphere, and the citizens made preparations for the events, which included a "cowboy" breakfast at 7:00 a.m., a parade, and ended with a Legion Dance. Stores were painted, and a rose garden was planted, as the town generally "brushed up" for the big celebration. (Courtesy of the Asotin County Museum.)

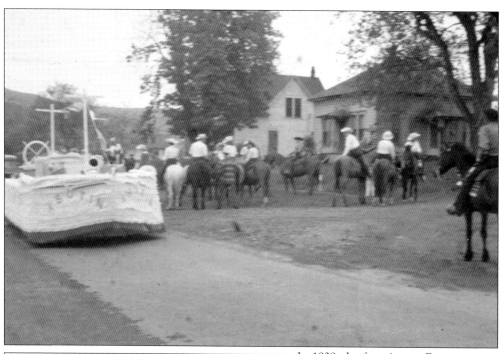

In 1939, the first Asotin Fair queen, Doris Floch, rode on a float similar to this one in the parade. Others in the parade were Mayor Joe Forgery on horseback, members of the city council, and the Clarkston high school band, who were the champions of eastern Washington. (Courtesy of Ken Powe)

Doris Floch, was the daughter of Mr. and Mrs. Chalsey Floch of Asotin Flats. She was a senior at Asotin High and was the official hostess. Princesses were Eunice Halsey (pictured), who is 95 years old at this printing, and Elizabeth Appleford. Both were from Anatone. (Author's collection)

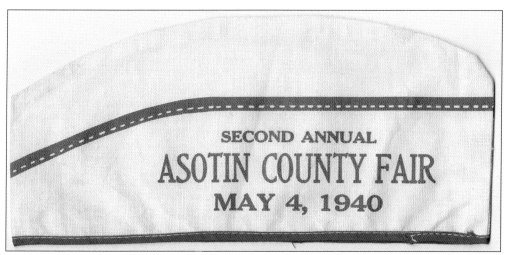

In 1940, a banquet was held to make plans for the coming market day. It was attended by 120 people from Asotin, Anatone, Rogersburg, and Clarkston. Two thousand paper hats were ordered to sell for 25¢ each as a money-making program and to be symbols of the event. (Courtesy of the Asotin County Museum.)

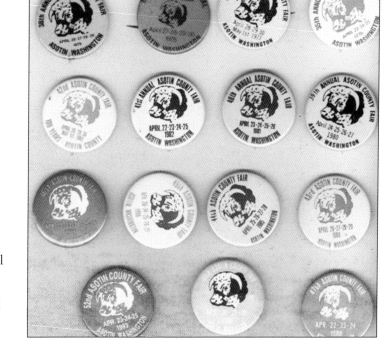

After two years of a successful fair, the fair board decided in 1941 to make it permanent. Either a button or badge with a bull's head on it was proposed as the official fair emblem instead of the paper hat. The same bull's head is still used today. (Courtesy of Bill Lintula.)

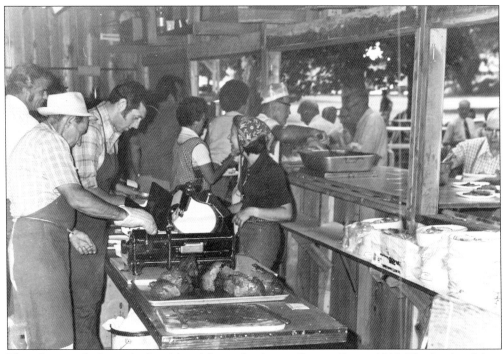

This photograph shows the Lion's breakfast at the Asotin County Fair in 1946. The first breakfasts were held at the park. (Courtesy of the Asotin County Museum.)

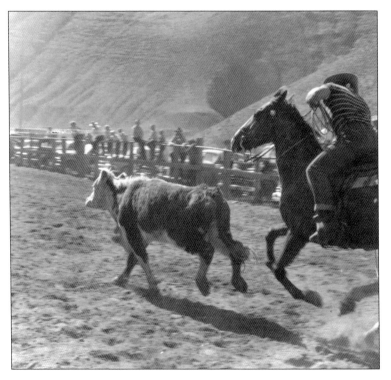

A large crowd is on hand to watch Bill White calf roping at the Asotin County Rodeo and Fair. The rodeo grounds were located in the area that is now the Asotin High School football field. Money made from the festivities was given to local charities for the good of the community. (Courtesy of the Asotin County Museum.)

The Asotin County Cattlemen and Cattlewomen Association did much to help Asotin and the Asotin County Rodeo and Fair. The Asotin County Cowbells took over the Friday afternoon barbecue for the boys and girls who had livestock on the fairgrounds. It soon became a main event. (Courtesy of the Asotin County Museum.)

Royalty is pictured at the Asotin County Fair around 1954. From left to right are Donna Plastino, Evelyn Greene, Sally Halsey, and Judy Adley. Each year, royalty was chosen from Asotin High School and surrounding schools. Sally's sister Janet Halsey was a princess at one fair. (Courtesy of Sally Halsey Glassaway.)

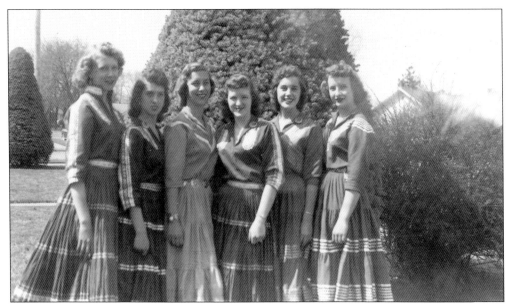

Asotin County Rodeo and Fair royalty are pictured around 1956. The queen was Kay Silver, shown here with her princesses. From left to right are Corrine Flynn, Arlene Tippett, Marilyn Schlee (Clarkston), queen Kay Silver, Susan Teague, and Zana Botts (Anatone). The chaperone that year was Bonnie Robeson. (Courtesy of Susan Teague.)

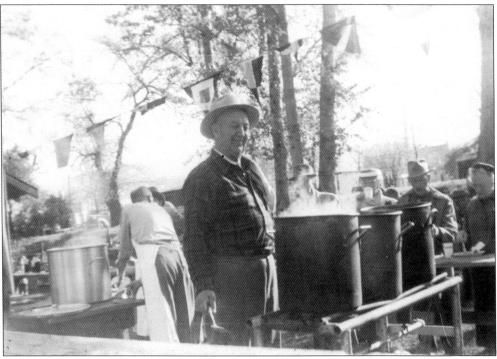

Earl Wilson, who owned the Wilson Banner Ranch, is shown making coffee at the fair. The following was written on the back of the photograph: "Earl Wilson pleased with his own efforts, making coffee at Asotin County Fair, April 27, 1957. When I say coffee, I mean FOLGERS." (Courtesy of the Asotin County Museum.)

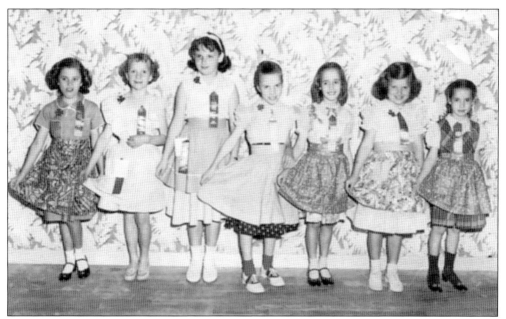

In 1958, these girls were the first 4-H group from Clarkston that had nothing to do with the livestock at the fair. Shown here in 1958 at the Asotin County Rodeo and Fair are, from left to right, Karen Victory-Pitner, Katie Clark-Ramsey, Jeanine Knutsen-Gautreau, Nancy Barnes, Betsy Plunkett-Paffile, Thelma Cornish, and Linda Plunkett-Nuxoll. (Courtesy of Karen Victory-Pinter.)

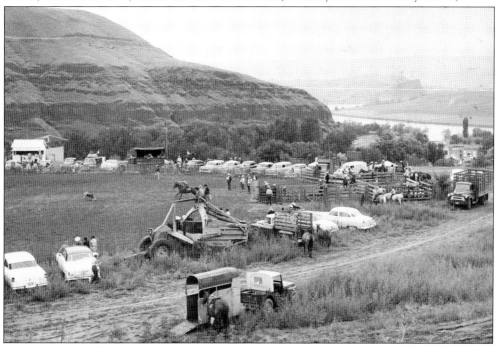

The name was officially changed to Asotin County Fair in 1961. In 1968, the name of the organization was changed to the Asotin County Civic Association. The rodeo was originally for local cowboys, who were as good as professionals and still are. Later, contestants came from miles around. (Courtesy of the Asotin County Museum.)

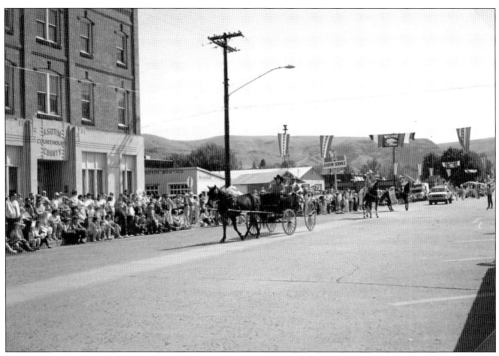

Bob Weatherby rides in a buggy at the Asotin County Fair parade. At different times, two governors of Washington were special guests of the fair. Gov. Albert Rossellini rode in the parade and was the speaker in 1960, and Gov. Dixie Lee Ray, who was quite a colorful character, rode in a buggy in the parade in 1980. (Courtesy of the Asotin County Museum.)

The construction of the first building for exhibits was in 1960. Dale Ausman was the chairman of the committee to get it completed. The building was named T.M. Floch Hall in honor of the longtime civic association president Travis Floch. Pictured is Vaden Floch. (Courtesy of Gary Floch.)

In 1962, people line up for the Asotin County Fair breakfast. In 1960, next to T.M. Floch Hall, another company building was erected and named Boyd Hall in honor of the longtime Asotin County home economist agent Rose Lee Boyd. (Courtesy of the Asotin County Museum.)

Shown waiting in line for the annual cowboy breakfast at the Asotin County Fair are, from left to right, Betty Hodges, Melba Hodges, LaVonne Hodges, Mary Hodges, and Delmar McMillian. The fair was always a good time to see and visit with old friends. People came from all the surrounding communities. (Courtesy of the Asotin County Museum.)

103

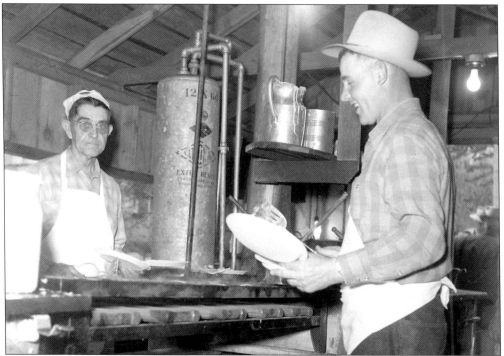

Charles Dorst (left) and Ken Floch are at the pancake breakfast in 1964. In 1939, the first free cowboy breakfast was new, so the organizers tried in every possible way to get the word out, encouraging people to invite their friends. They were afraid some people would be too shy unless they were asked to come. (Courtesy of the Asotin County Museum.)

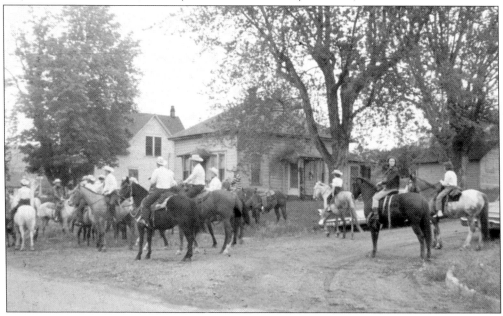

Cowboys line up for the Asotin County parade around 1968. Parking for the Asotin County Fair was handled by the Asotin County Sheriff's Posse, which was organized under Sheriff Hugh Curry in 1960. It handled parking control for many years. (Courtesy of Ken Powe.)

The Saturday morning parade continues to be a popular and well-attended event. Many surrounding high school bands participated in the parade until the Lewiston Music Festival began on the same weekend and the number of participants dropped. But that did not keep the people from coming. (Courtesy of Bill Lintula.)

The fair had all kinds of food for everyone. After the parade, there are concessions at different locations where food may be acquired. For many years, the noon meal was served in the Methodist church. Later, the noon meals were served by the Eastern Star organization in the Masonic Hall. (Courtesy of Bill Lintula.)

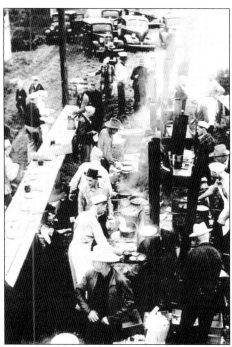

While the cowboy breakfast went on, there was some unrest over the change in management, and for some time, there was talk of moving to a new fairground location west of Clarkston Heights. The issue was finally settled in 1976 when the title to the fairgrounds was transferred to the county. (Courtesy of the Asotin County Museum.)

A large carnival sets up each year in Asotin and is a favorite of the young and the young at heart. It is pictured here in 1977. The Asotin Lions Club, the Grange, the Wheelers, the Asotin County Cattlemen and Cattlewomen Association, and many other organizations contributed to the success of the Asotin County Fair. (Courtesy of the Asotin County Museum.)

The Asotin County Fair carnival is shown here in 1977. The carnival has been well attended through the years, as people also come from surrounding communities. Many teenagers from Lewiston and Clarkston make it an event not to miss; some even going so far as to buy matching shirts. (Courtesy of the Asotin County Museum.)

George Bott is shown with his wife, Maxine, during the parade. George was president of the Asotin County Cattlemen and Cattlewomen Association in 1990. The Botts were popular parade marshals. (Courtesy of the Asotin County Museum.)

Esther Anderson is shown here ready for the 1991 Asotin County Fair. She was the secretary of the first Asotin Fair Association in 1939. She was well known and much loved in Asotin, as she was especially loving towards the children of the area. (Courtesy of Judy Ward Karlberg.)

Eight

DESTRY RIDES AGAIN

CLARKSTON, APLOWA, AND PEOLA

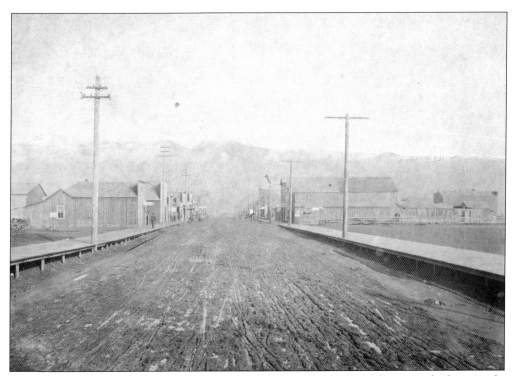

This is a photograph of Sixth (Main) Street in Clarkston around 1900. The view is looking north, and there are wooden sidewalks, a dirt street, and utility poles visible. In 1896, the year the water came through the big ditch, John Kidd opened the first grocery store at 902 Sixth Street. Jawbone Flats and Concord were some of the names tried before they settled on Clarkston. (Courtesy of the Asotin County Museum.)

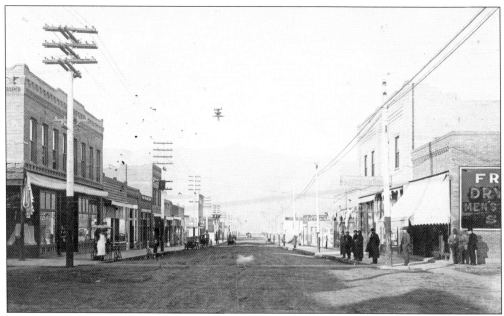

This is Sixth (Main) Street in Clarkston, five miles down the river from Asotin. Clarkston boomed during its infancy. Speculation as to where the railroad would come in within a year or so was heard, and that contributed to its growth. (Courtesy of Sherry Ross Willenborg.)

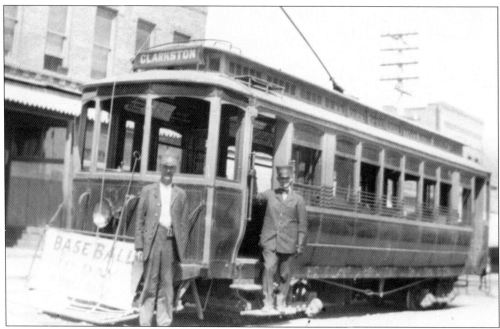

In 1913, Lewiston-Clarkston streetcars were located on the main street in Clarkston and in front of the Lewiston train depot in Lewiston. Henry True is the conductor; the other man is unidentified. There was a carbarn at the northeast end of the interstate bridge, and a zoo of sorts there. (Courtesy of the Asotin County Museum.)

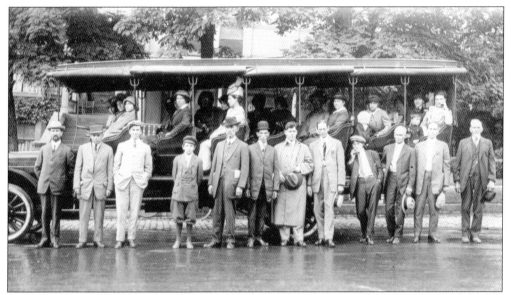

This photograph shows Stephen Badger standing at far right by the bus. The date is believed to be before 1918. Badger was a truck farmer and grew fruit. One of his regular crops was peaches. (Courtesy of Shelly Ross Willenborg.)

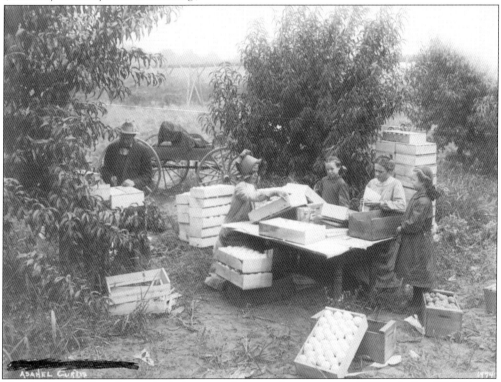

Noted photographer Curtis Asahel captured this packing party in 1905 with Guy W. Wilson's family. Two women and two girls pack peaches while a man builds fruit boxes. Note the hammer, the wagon with lap robe, bow ties, overalls, fedora, bonnet, and the metal can on the table. There is also a newspaper under the table. (Courtesy of the Asotin County Museum.)

This is the 109th anniversary gathering of the Independent Order of Odd Fellows. The photograph was taken in 1928 at Vernon Park in Clarkston. Note the Carnegie Library and the high school in the background. This photographer worked in Lewiston from 1927 to 1931. (Courtesy of the Asotin County Museum.)

This vine-covered cottage at Fifteenth Street and Pound Lane in Clarkston belonged to M.V. Pound. It is shown on August 29, 1910, in Clarkston Heights. A wagon is visible at left, a bicycle is in front of house, and a woman is shaking laundry in the backyard. The building is no longer standing. This is another Curtis Asahel photograph. (Courtesy of the Asotin County Museum.)

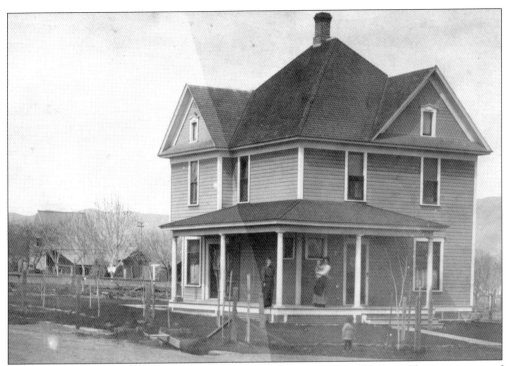

Stephen and Nannie Badger's house is still standing at 1346 McCarroll Street. They spent most of their married life in Clarkston, where he had a service station. They had four children, but none are now living in Clarkston or Lewiston. Del Willenborg and his parents lived at 1346 Twelfth Street (across from the hospital), and he remembers that the McCarroll house was later called the Vowell house. (Courtesy of Sherry Ross Willenborg.)

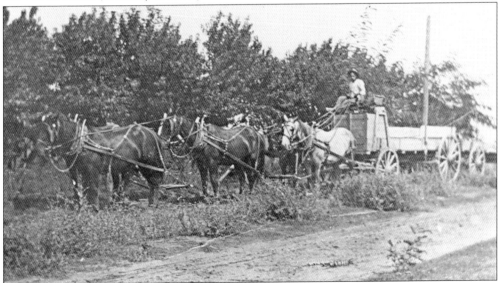

In 1908, Roy Sweet, age 18, is shown driving the wheat wagon for William L. Ladd of the Clemans Addition. Note the five horses, and the orchard in the background. William Ladd owned 1,100 acres. Roy hauled wheat to Vollmer's (old Charles Isecke's) mill on Asotin Creek and to Lewiston, Idaho. (Courtesy of the Asotin County Museum.)

This picture was taken in 1948 of the third grade class in Clarkston. The class was held in the basement. The building was called Smith Hall and was located north of the existing high school and south of the old library. It has long been torn down and replaced with another building. There was an auditorium or gym on the top floor and classrooms in the basement. Russ Mason is pictured at far right in the first row. (Courtesy of Russ Mason.)

This is a view of Clarkston Heights in 1910. Note the windbreak, the farm in the background, the cattle at left, and the haystacks. After irrigation came to Clarkston Heights from the headgates of Asotin, the land began to bloom. Crops of wheat, fruit, and flowers were everywhere. (Courtesy of the Asotin County Museum.)

This photograph shows a convertible automobile under a tree at the E.R. Windus place in Clarkston on October 3, 1910. Note the chestnuts in the tree and the roses in the foreground. (Courtesy of the Asotin County Museum.)

This is the home of pioneer E.H. Libby at Thirteenth and Chestnut Streets in Clarkston. Critics noted that the trees and vines greatly made up for the poor architecture. Libby and Charles Francis Adams were instrumental in bringing irrigation to Clarkston and Clarkston Heights. Adams was the grandson of Pres. John Quincy Adams and the great-grandson of Pres. John Adams. (Courtesy of the Asotin County Museum.)

Cliff Wasem's grandparents were F.W. and Daisey Dustin, who moved to Clarkston in 1898 and built one of the nicest homes in the area. As folks discovered Clarkston, they planted orchards, gardens, and lawns. Water from the big ditch built between Asotin Creek and Clarkston helped to transform the desert into a town. This photograph was taken in 1926. (Courtesy of the Asotin County Museum.)

This was the home of a nurseryman in 1910. It was located at Ninth and Highland Streets. Note the fence, the street, the chairs on the porch, and the windows with lace curtains. The design detail on the gables, columns, and screen door were popular at the time. A reel lawn mower is seen at right in the side yard. (Courtesy of the Asotin County Museum.)

Max L. "Lafe" Wilson sits on his brother Joe's shoulders for a picture in 1958, showing just how tall the corn has grown. (Courtesy of the Asotin County Museum.)

This is the Indian Chief Timothy Memorial Bridge on US Route 12 spanning Alpowa Creek. (Courtesy of the Library of Congress.)

Eugene Wilson is shown on the left in this late 1800s picture of John Silcott's ferry, with the Snake River in the background. The man on the right is unidentified. The ferry was the only way to cross the river until 1905, when the 18th Street bridge was built. (Courtesy of the Asotin County Museum.)

This is the old Potter Hotel on Fifth and Sycamore Streets in Clarkston. The hotel no longer exists. In the late 1920s and in 1930, the Clarkston Chamber of Commerce promoted what was called the Harvest Festival in late September. The businessmen and merchants took part enthusiastically, decorating their places of business in fall colors. (Courtesy of the Asotin County Museum.)

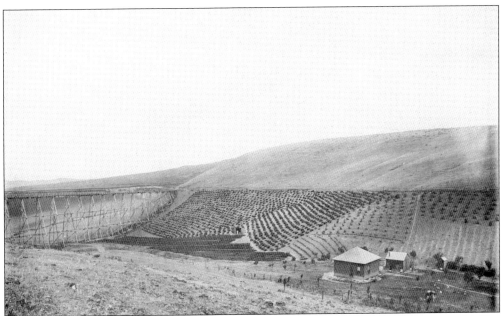

This photograph shows the home Phoebe J. Paffile moved to when she was six years old. Her sister Tressie N. Brooks was four. Her parents were Fabian Brooks and Cecil R. Skinner Brooks. Her grandmother Olive J. Skinner was a local midwife. Her father started planting this place about 1901. Only one other person, a bachelor, lived on this road to Clarkston Heights then. The flume at left center carried water to Clarkston from Asotin Creek. (Courtesy of the Asotin County Museum.)

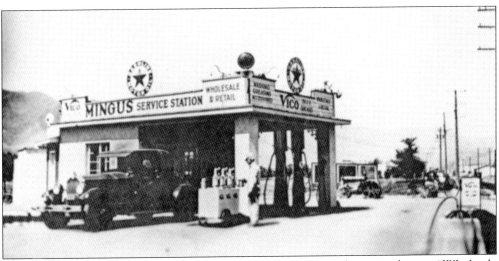

This was the Mingus Service Station in Clarkston in the 1930s. The signs advertise "Wholesale & Retail, Washing, Greasing, and Accessories." The rolling hills can be seen in the background. (Courtesy of the Asotin County Museum.)

"Woodbine and clematis thrive here as if to the manor born" was written on the back on this photograph. This home at Thirteenth Street and Sixteenth Avenue in Clarkston was the winner of a prize for grapes in 1910, in competition with the entire Pacific Coast. (Courtesy of the Asotin County Museum.)

This was the lovely home of Ingvar Peterson at Thirteenth and Highland Streets in Clarkston in 1910. Note the design details on the rails, the spans between columns, the gable facade, and shingles on the second-story facade with a sleeping porch. This photograph was taken by Curtis Asahel. The home is no longer standing. (Courtesy of the Asotin County Museum.)

This is a 1920s photograph of the Wilson Banner Ranch. Weldon Wilson was inspired by editor Horace Greely's "Go West Young Man." One day in 1886, he walked into the Alpowa Creek valley and saw the potential in the sagebrush-covered hills. Thus began a familiar landmark that is still operating in Asotin County—the Wilson Banner Ranch. The Weldon Wilson home is shown in front of the greenhouse and barn. In front of the house is a newly planted peach orchard. The farm is located in the Silcott area of Asotin County, about 10 miles west of Clarkston. (Courtesy of the Asotin County Museum.)

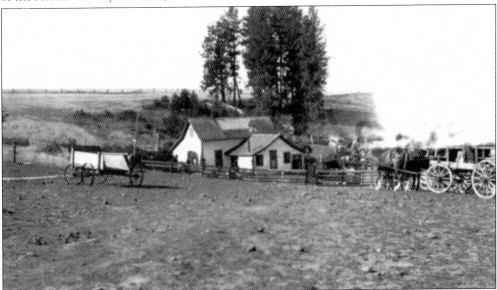

This is Bob Weatherly's ranch in Peola. Robert Weatherly dedicated many years to the collection, recording, and presentation of Asotin County history. His series of Jawbone Flats books were filled with information about the area. (Courtesy of the Asotin County Museum.)

This photograph shows where Silcott Island is today, at center where the boats can be seen. It has been renamed Chief Timothy State Park and is a very popular boating and camping area. Named Aplowa, said to mean "Sabbath" or "place of rest," the island was said to have been given by Tima, wife of Chief Timothy. Silcott is now a ghost town. (Photograph by Marcia Darby.)

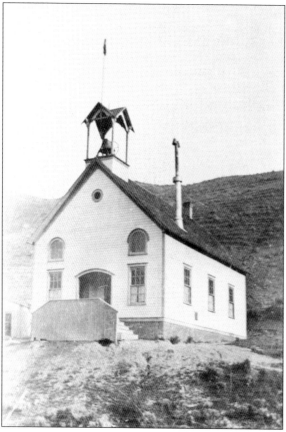

This was the Silcott School house in 1914. The Silcott area was first settled in the late 1880s and has been overlooked by history. In 1910, Silcott was made up of two general stores, warehouses, a school, and homes and orchards, which were later destroyed with the coming of the Lower Granite Reservoir. Today, very little exists as proof of Silcott's existence outside of the abandoned cemetery. (Courtesy of the Asotin County Museum.)

This photograph of the Wilson brothers was taken in 1911 in front of the original family home on Wilson Banner Ranch. From left to right are (first row) Mac, Gene, and Earl; (second row) Lloyd and Lafe. The house burned down in 1913. (Courtesy of the Asotin County Museum.)

The young daughter of Weldon Wilson is shown taking a bath in a tub in front of the stove in the kitchen. This was not an unusual sight for families during that time before running water and all the luxuries of today. (Courtesy of the Asotin County Museum.)

A group of women and children are shown outside the first Silcott School. The boy with the cap (first row, right) is Lafe Wilson. In the second row, Lolly Wilson is third from the left and Lloyd Wilson is third from the right. The others are unidentified. (Courtesy of the Asotin County Museum.)

In this wonderful photograph by Curtis Asahel, J.W. Lipe is feeding his chickens on the Lipe Farm in Clarkston in 1910. Note the feed bag and the trough at right. Most farmers had chickens not only for food, but also to sell on the corners of Clarkston streets. (Courtesy of the Asotin County Museum.)

This photograph, taken in 1952 in front of the Clarkston beach house, shows two brothers, Kenny Heintz, age nine, and Tim Heintz, age three, as they beat the heat at the Clarkston Beach. The beach house was popular with children as it was a place to buy treats. (Courtesy of Tim Heintz.)

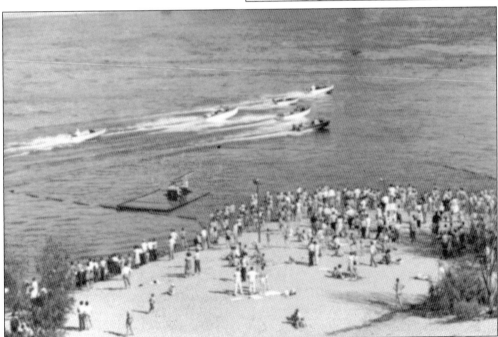

The Snake River boat races were always a major attraction during the 1950s, and they still are today. Cassell's Marina in Clarkston, one of the marinas on both sides of the Snake River, was particularly busy, as they sponsored some of the races. (Courtesy of the Asotin County Museum.)

Del Willenborg is shown holding a steelhead he caught below the Swallows Nest around 1952. Willenborg has always enjoyed bank fishing and landing and fighting fish. He was a resident of Clarkston at the time. He is a 1953 Charles Francis Adams High School graduate. (Courtesy of Del and Sherry Ross Willenborg.)

Mac Wilson sits on the lap of an unidentified woman at left in this photograph from around the turn of the 20th century. Sarah Ann Baker holds her grandson Earl Wilson at right. The other two adults are unidentified. (Courtesy of the Asotin County Museum.)

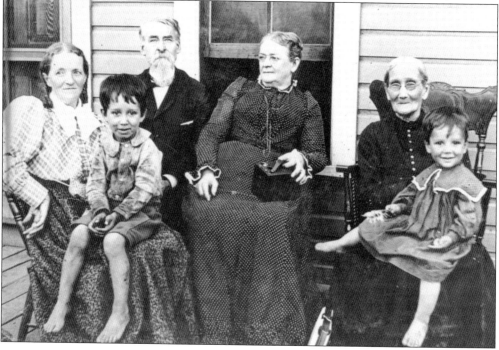

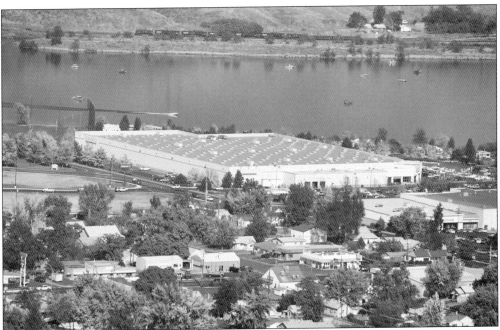

Eighty-seven-year-old Marvin Jackson's parents were Henry Lynn Jackson and Margarett Jackson. His father worked for a developer in Clarkston and planted clover on the land from Costco (pictured) to where the country club is located today His parents met around 1926. His father later went to work at the Dustin Cannery, where the water center is now located. Marvin, who is the Port of Clarkston commissioner, was the grand marshal of the fair in 2016. So far, he has only missed two fairs since 1946. (Courtesy of Virginia A. Sarbacher, V-n-R Imagery.)

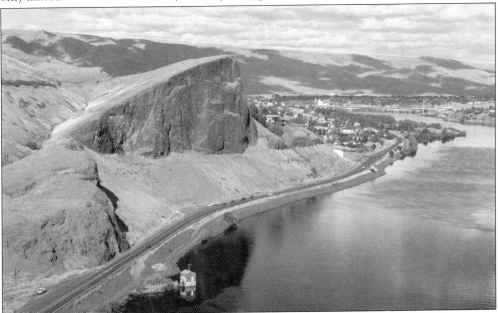

Asotin County is recognized as a region of outstanding beauty and historical significance. Known as part of the Banana Belt since the 1920s, the county enjoys a mild climate, allowing for year-round outdoor recreation. (Courtesy of Brad Stinson.)

Discover Thousands of Local History Books Featuring Millions of Vintage Images

Arcadia Publishing, the leading local history publisher in the United States, is committed to making history accessible and meaningful through publishing books that celebrate and preserve the heritage of America's people and places.

Find more books like this at
www.arcadiapublishing.com

Search for your hometown history, your old stomping grounds, and even your favorite sports team.